JAN KUNZ
WATERCOLOR
TECHNIQUES

D0993224

Marian —
Best wishes for
every success —
Jan Kunz

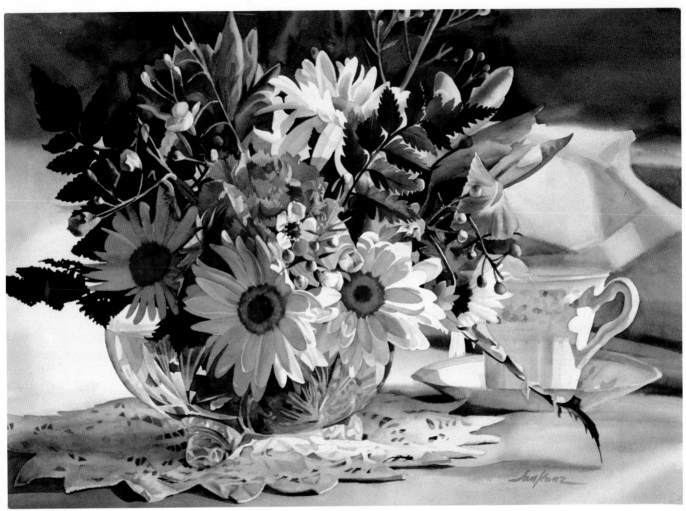

Afternoon Tea
Jan Kunz 30″ × 20″

JAN KUNZ
WATERCOLOR TECHNIQUES

NORTH LIGHT BOOKS

CINCINNATI, OHIO

DEDICATION

This book is dedicated to Greg and Bill Kunz with love and gratitude for their unbounded support.

Jan Kunz Watercolor Techniques. Copyright © 1994 by Jan Kunz. Printed and bound in Hong Kong. All rights reserved. No part of this book may be reproduced in any form or by any electronic or mechanical means including information storage and retrieval systems without permission in writing from the publisher, except by a reviewer, who may quote brief passages in a review. Published by North Light Books, an imprint of F&W Publications, Inc., 1507 Dana Avenue, Cincinnati, Ohio 45207. 1-800-289-0963. First edition.

98 97 96 95 94 5 4 3 2 1

Library of Congress Cataloging in Publication Data

Kunz, Jan
 [Watercolor techniques]
 Jan Kunz watercolor techniques / Jan Kunz.
 p. cm.
 Includes index.
 ISBN 0-89134-567-1
 1. Still-life painting—Techique. 2. Watercolor painting—Technique. 3. Children—Portraits. 4. Portrait painting—Technique. I. Title. II. Title: Watercolor techniques.
ND2290.K86 1994
751.42'242—dc20 94-1967
 CIP

Edited by Rachel Wolf
Designed by Brian Roeth
Cover illustration by Jan Kunz

METRIC CONVERSION CHART		
TO CONVERT	**TO**	**MULTIPLY BY**
Inches	Centimeters	2.54
Centimeters	Inches	0.4
Feet	Centimeters	30.5
Centimeters	Feet	0.03
Yards	Meters	0.9
Meters	Yards	1.1
Sq. Inches	Sq. Centimeters	6.45
Sq. Centimeters	Sq. Inches	0.16
Sq. Feet	Sq. Meters	0.09
Sq. Meters	Sq. Feet	10.8
Sq. Yards	Sq. Meters	0.8
Sq. Meters	Sq. Yards	1.2
Pounds	Kilograms	0.45
Kilograms	Pounds	2.2
Ounces	Grams	28.4
Grams	Ounces	0.04

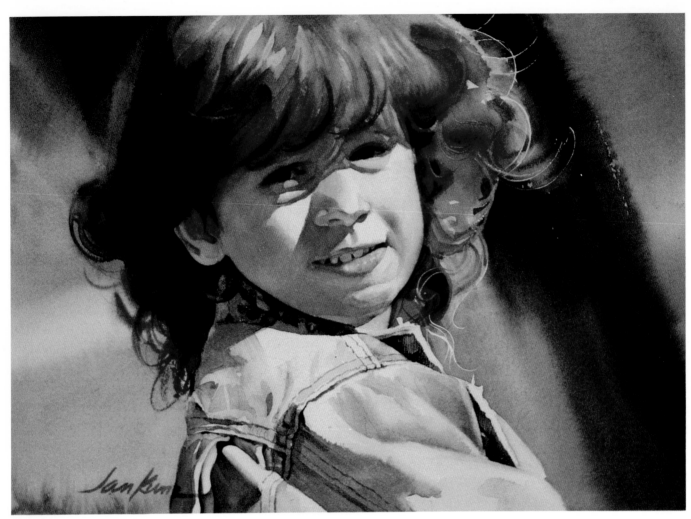

Tyler Ann
Jan Kunz 22″ × 15″

■ CONTENTS

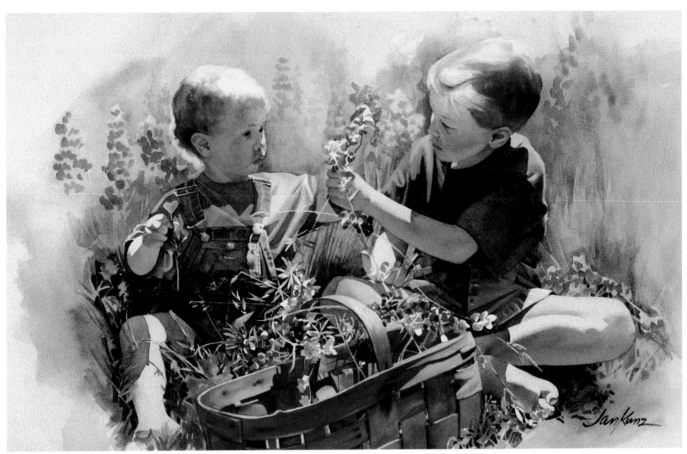

Untitled
Jan Kunz 30″ × 22″

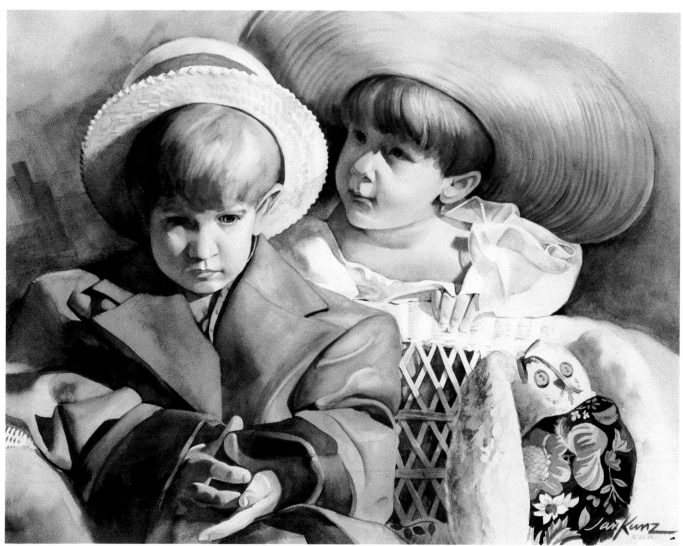

"Have You Heard?"
Jan Kunz 22″ × 30″

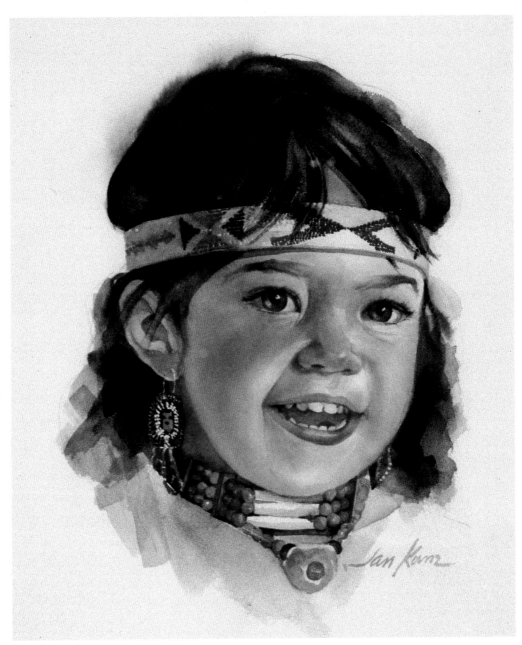

Next Generation
Jan Kunz 9″ × 11″

■ INTRODUCTION

HOW TO USE THIS WORKBOOK

This workbook is designed to help you master the elements of the still life and portrait one at a time. There are two sections with six projects in each. The first section will teach you how to paint the basic components of the still life. The second section will show you the components of painting children's portraits. Each project is accompanied by a practice drawing (drawings on pages 70 through 81) that you can trace onto your own watercolor paper. You can practice each one over and over until you feel confident in your new skills.

Every part of this workbook has been carefully designed to be used. There's the introduction, which you are reading now, the twelve practice drawings mentioned above, a set of special instructions for each section, and the twelve projects. Each project has five pages. The final page shows you what your finished project should look like.

I suggest you look over the contents of the whole workbook to familiarize yourself with it. Then turn to the pages for the first project and read over the instructions in their entirety before beginning to paint.

MATERIALS AND TOOLS

I have come to believe from experience that a few simple tools are better than many complex ones. Over the years I have pared down my painting equipment to the basics. Here is a list of all the tools and materials you need to complete the projects in this book.

Paper. Any good watercolor paper will do. I use Arches 140- or 300-pound paper. There are other good papers available which you can check out at your art supply dealer. You don't have to use the most expensive paper, but it pays to use the best you can afford.

Palette. Like so many of the choices of materials, selecting the right palette is a personal one. I use a large Winsor & Newton folding model that is no longer available. It is very similar to the Holbein #1000 available in art stores. A smaller model of the Winsor & Newton palette (No. 500) folds into a convenient size for traveling. I like this style because I can arrange warm colors on one side and cool ones on the other. When I reach across the palette, I know I'm picking up a complementary color. This is useful when we begin to mix sparkling dark colors. I use a butcher's tray whenever I need a large puddle of color.

The palette you use isn't as important as knowing exactly where every color is located. Finding the color you need without having to stop and search for it is often critical to painting a large area successfully.

As a matter of taste, I prefer the baked enamel palettes to the plastic ones. They are easy to keep clean with the wipe of a tissue, and they do not stain. When selecting your own palette, look for one that has a large area for mixing washes and deep wells for holding pigments.

Pigments. I use Winsor & Newton colors most of the time, although I have used Holbein, Grumbacher, and Liquitex. All are fine paints, but sometimes pigments with the same name will vary in color according to the brand. I use the following watercolor pigments (all are tube colors): alizarin crimson, Winsor red, cadmium red, cadmium red deep, rose madder, new gamboge, cadmium orange, raw sienna, burnt sienna, raw umber, burnt umber, Payne's gray, cerulean blue, cobalt blue, ultramarine blue, Winsor blue, Winsor green, sap green.

Brushes. It has been said that a craftsman is as good as his tools. Likewise, it is certainly much easier to paint with a good brush than a poor one. It is easy to spot a wimpy brush. Once you use it, it has a way of remaining at right angles to the handle and refuses to respond.

Recently I found some good synthetic brushes. If you aren't sure, buy one and try it. It should be springy, hold a good point, and hold plenty of water. Here is a list of the brushes I use. Most of them are synthetic: 1″ flat, ½″ flat, no. 4 round, no. 6 round, no. 8 round, no. 12 round.

In this workbook, when I say "small" brush, I'm referring to the no. 4 or 6. I use larger brushes for large areas. It is always best to select a brush size appropriate to the area you are painting.

In addition to these watercolor brushes I have modified two oil painter's bristle brushes. I trimmed straight across the tip of a ½″ brush to make it stiffer, then cut the tip of a no. 2 round synthetic brush at an angle. I use these brushes to scrub out color in my paintings. The small tip of the round brush works great

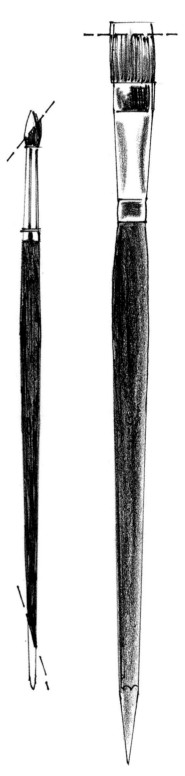

This diagram shows how I have modified two types of bristle brushes which I use for scrubbing out color.

in tight places.

Water Containers. I prefer very large water containers. The water stays cleaner longer, which is essential to mixing unmuddied colors.

Paint Rag. A really important and often overlooked piece of equipment is a good paint rag. I use a small terry cloth towel which I keep between my palette and my painting. Old bar towels, the kind restaurants and bars use to wipe up spills, or flat cloth diapers are also good.

I rarely go directly from my palette to the paper or from the water container to the paper without first touching the brush to the towel. I do this to adjust the amount of water in the brush, a critical step in the painting process. Too much water and it is difficult to control; too little and the paint won't flow.

I have seen many dirty sponges and almost useless rolls of toilet paper serve as paint rags. Use a clean paint rag every time you paint.

Studio. Having a comfortable, well-lit, convenient place to work is important. You want to find a place that you can devote to your art without too many distractions or interruptions. You'll need a table large enough to hold your paper and its support, the palette and water containers, and still have room to place this book with the instructions in view. You will also need good light positioned so you aren't working in your own shadow. Before I had a studio I used to paint on the kitchen sink after the family went to bed. If that is where you are in your career, make the best of it! The rewards are worth the hassle.

DOING THE PROJECTS

The first step for each project is to transfer the practice drawing, found at the back of the book, following the instructions on page 69. Then follow the painting demonstrations step by step. Once you begin to paint, keep a scrap of watercolor paper handy on which to practice any passage you may find difficult before attempting it on your painting.

I recommend you try the same project a number of times, varying the colors and values to make your own discoveries about watercolor.

Complete each project in the order presented. When you have finished them, you will have gained all the basic skills you need to paint glorious watercolors. You can then go on to paint your own original still lifes, portraits or other subjects.

Painting Procedure

Once you have transferred your drawing to the paper, you are ready to paint. All the projects in this book follow four basic steps. Once you are familiar with them, you can use them for your own paintings. These four basic steps are:

1. Wash in the local color of the objects.
2. Paint the shapes of the shadows.
3. Model the forms.
4. Finish by painting the details and "crevice darks."

"Crevice darks" are what they sound like. They are warm darks in the cracks and crevices of objects where light doesn't reach. A "crevice dark" is a relatively thin wedge of color that tends to solidify the form of an object.

When I work, particularly in steps two and three, I like to drop in or "charge" color into the wet paper. This is how I get colorful, interesting shadows. However, handling the blending of wet color on wet paper can sometimes be tricky. If at any time you find you are losing control of the paint, try this: Paint as far as you can comfortably, and then let it dry. After you are sure of the next step, remoisten the surface around where you left off with clear water and begin again with the same value pigment. The color will blend together at the edges.

The six projects in each section are arranged in an intentional order. For the first three projects in the still life section, I chose four popular elements of the still life and broke them down into simpler components. The last project puts many of these same objects together into a complete still life. In the portrait section, I start with a simple head and move on to more complex poses, ending with a group portrait. Because each project builds upon the one before, I suggest that you do them in the order provided. As I mentioned before, you might want to complete all or some of the projects more than once.

On the following page, I have summarized important information on light, shadow, value and edges.

EDGES

Painting edges is one of the most important skills for the watercolor artist to master. There are four types: sharp, rough, soft and lost. Each has a special use. Things in focus have sharp edges, as do most hard, angular shapes. Round, soft or distant things have soft, indistinct edges. Objects with very irregular surfaces have rough edges. Lost edges are borders between areas of equal value where no edge is discernible.

To soften an edge on dry paper, work from the unpainted side and use a clean damp brush.

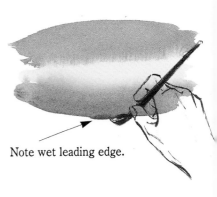

Note wet leading edge.

You need to use a fully loaded brush and keep your color wet (see wetness scale on page 3) when you are dropping in color for reflected light or shadow colors. This will allow the color to blend properly without feathering like it does when you drop color into a puddle.

Each type of edge is made with a different wetness of paper. To get a hard edge, paint with a brush charged with wet pigment onto dry paper. To get a rough edge, paint lightly with a dry brush (actually damp but not dripping with color) on dry paper. To get a very soft edge, paint with a charged brush on wet (still glistening) paper. To get a soft, controlled edge, paint with a wet brush on moistened (but not glistening) paper.

To get a very diffused, uncontrolled spreading of color, dip a brush loaded with paint into water puddled on the paper and let it alone as the color spreads and "blossoms" on its own. Sometimes when I want to add a different color into a still-wet application of paint for more interesting color, I will "float" the color in by just dipping the tip of a brush loaded with the new color onto the still-wet paint. Finally, to get a "feathered edge," that is, one that is hard along one edge and faded out to the other, paint along the line that will be the hard edge and then, while it is still wet, use a brush wet with clean water to soften and diffuse the edge away from the hard line.

THE LAWS OF LIGHT
Understanding how light works is an essential part of mastering any painting. Let's look at the four rules I call the "laws of light."

Light and shadow reveal the true form of what we see. The strongest illusion of solid form is created by a convincing pattern of light and shadow, so the first rule to remember is: *There must be only one source of light.*

One light source creates two main values in your painting, a light value in the sunlight and a dark value in the shadow. The exact value depends on the local color of the subjects and any reflected light bouncing off nearby surfaces.

If you look closely at buildings, trees and other objects on a sunny day, you may observe the second rule, which is what many landscape painters know: *All horizontal surfaces facing the sky are cooler in color temperature than vertical surfaces.*

The 40 Percent Rule
The third rule is another observable fact: *Objects viewed in sunlight have sunlit sides approximately 40 percent lighter in value than their shadow sides.* Since we humans can distinguish something like ten to twelve different values, it becomes a simple matter to approximate this 40 percent difference. Using a value scale with ten uniform steps of gray from white to black numbered from one to ten, an area in light would be four steps (40 percent) lighter than the area in shadow if the local color is the same. Cast shadows are somewhat more than 40 percent darker than the objects upon which they are cast. This simple information can eliminate the ever-occurring question of how dark to make the shadow side.

I suggest you make a value scale with ten steps from white (value 1) through ever-darker shades of gray, to black (value 10) and keep it handy when you paint. When I refer to a value number (value 4, value 1, etc.) in the projects, I am referring to its placement on this value scale.

In addition to these important value relationships, rule four is an exciting thing to know: *The shadow side may show reflected light bouncing off an adjacent object.* This opens the door to beautiful (and believable) color on the shadow sides of the people and objects we paint!

JAN'S SCALE OF WETNESS
When working with watercolor, the wetness of the paper is often the most important element in making the paint do what you want it to. Painting with control often means controlling the amount of water on the paper. In the instructions in the following projects, I will refer to the wetness of the paper with various terms. To avoid confusion, I'll use these terms as defined and illustrated at right.

▲**Dampen:** When I say dampen the paper, I mean wet it so the paper has absorbed some water, but is not saturated.

▲**Moisten:** When I say to moisten the paper, I mean to wet it so the paper has absorbed all the water it can hold.

▲**Wet:** When I say wet the paper, I mean to wet the paper beyond saturation so water stands on the surface and glistens in the light, but does not puddle.

▲**Puddle:** When I say puddle the water on the paper, I mean to apply enough water so that it puddles in a pool on the paper.

PAINTING THE STILL LIFE

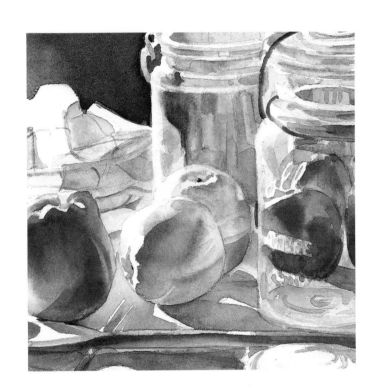

HOW TO SET UP AND PAINT YOUR OWN STILL LIFE

After you complete the projects in this workbook to your satisfaction, you will want to go on to the exciting challenge of creating and painting your own still life arrangements. To help you get started, here is some helpful general information about the still life.

Choosing Still Life Objects

First, choose meaningful objects. Find things that you like or that have some personal meaning, rather than things you think are "arty." I like to echo a theme by selecting things that belong together, like mementos from a trip that I have taken. Once I have selected some objects, I look for a variety of forms, some interesting textures and harmonious colors.

Setting Up the Still Life

Arrange the objects carefully. Keep in mind the overall shape of the objects taken together. Do they form a circle, a triangle or some other shape? How does the arrangement of the shapes fit on the rectangular shape of the paper? Remember, perfect circles, squares and equilateral triangles are less interesting than more irregular shapes.

Take away and add objects until you feel the arrangement's right. I always make a small sketch to see how it will work with the shape of the paper.

Painting the Still Life

The first step is making a good drawing. The time spent preparing a good drawing is always rewarded. Don't be in too great a hurry to start painting before you have given careful attention to the drawing—you can't make a great watercolor from a weak drawing. Use tracing paper overlays to clarify and refine your drawing. After you have finished the preparatory drawing, transfer it to the watercolor paper with the graphite tracing paper.

Here are some tips to make a good drawing from life. Pick the most revealing point of view. Most objects have shapes that reveal the identity from one angle but obscure it from another, so let the shapes in your drawing explain themselves. All objects can be broken down into combinations of four basic forms—cube, cone, cylinder or sphere. Even a complex object can be easier to draw if you first analyze the simpler shapes that make it up. There must be room for each object in your drawing—"draw through" objects so you can see how the objects fit to avoid creating an unrealistic placement of objects in your drawing. It helps to establish the proportion of the largest object first, and to make the other objects to that scale. Light and shadow add drama and color, but basic drawing must be able to stand by itself.

Still life painting can be a wonderfully satisfying experience for the rank beginner as well as the master painter. It can be as simple as you wish it to be, or it can be one of the most intricate or expressive of subjects. As you continue painting, you will find your unique way with this subject that artists have painted in so many different ways over the centuries.

Often it is the artist's approach that makes a still life a fine painting. It is the artist's ability to express a universally recognizable feeling about beauty and life that makes any work "art."

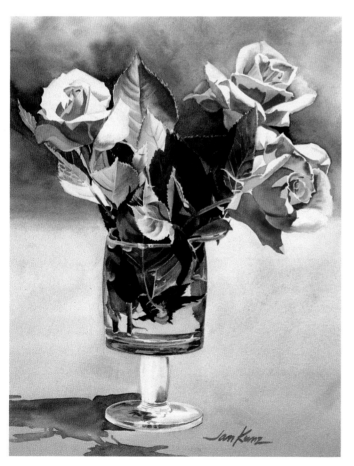

Roses in a Glass
Jan Kunz 15″ × 20″

■ PROJECT 1: GLASS JAR WITH ROSE

In this exercise you will learn how to paint two very important elements of the still life: a transparent object and a single flower. I think you will find that these objects are not nearly as difficult to paint as many people feel they are.

STEP ONE

1. Wet the jar with clear water, carefully avoiding the lettering to keep it white. Add raw sienna to the right side, making it darker where it approaches the right edge. Add pale cobalt blue to the left side.

2. When thoroughly dry, rewet the jar, avoiding the lettering, and add a darker blue at the bottom, blending toward green with the addition of warm umber on the right side.

3. Keeping the surface dry, paint the shapes (reflected around the lip of the jar) using the same colors as before. Make value adjustments as required.

STEP TWO

1. With the paper dry, begin with the large leaf behind the lettering and carefully paint around each letter. After the jar is dry, use cobalt blue to paint in the raised lettering where the thickness of the glass has made the shape darker. Also add this color to other areas of the lettering which cast a shadow or otherwise appear darker.

2. Wet the area of the background and add a very light value of color: raw umber in the foreground, becoming a cooler blue-green in the background. Even this small color temperature difference will keep the foreground up front, and will allow the background area to "lie flat."

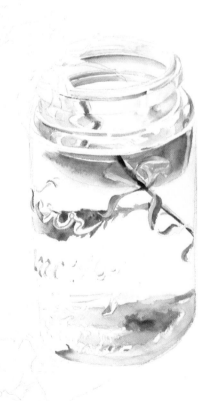

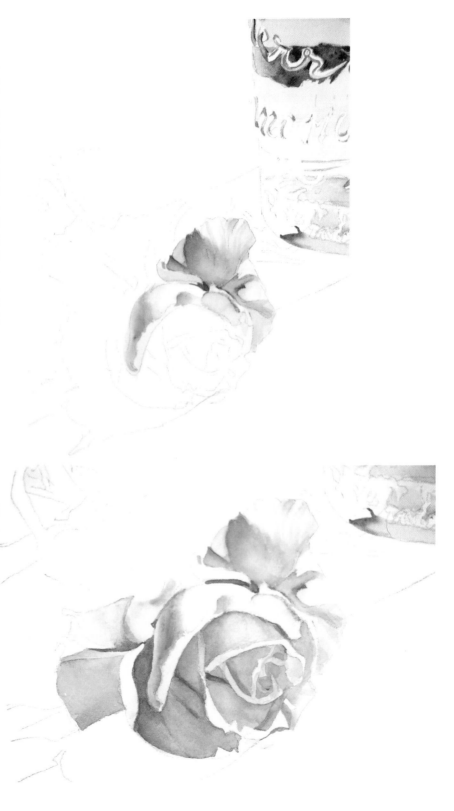

STEP THREE

Begin the lower rose. Observing the "laws of light," make all the vertical surfaces warmer than the horizontal surfaces. The portion of the rose that is horizontal is painted with a light value of alizarin crimson. After that color is dry, rewet the surface and add cadmium red and new gamboge to suggest reflected light. Before that has a chance to dry, add alizarin crimson for the area in shadow. The edge is kept soft to enhance the roundness of this area.

STEP FOUR

Now, observing the laws of light, complete the lower rose, using alizarin crimson, new gamboge, cadmium orange, burnt sienna, and a touch of red violet (alizarin mixed with cobalt blue). The darkest areas are burnt umber plus alizarin crimson.

STEP FIVE

1. Paint the cast shadow a rather grayed green. You can paint the cast shadow in two stages using the dark stem of the rose to hide the separation. Mix the color for the shadow with Winsor blue and raw umber. Beginning on the left side of the rose, paint carefully around the petals.

2. In the next step you will be painting the "hot spot" to the right of the rose where the sunlight strikes the bottom of the jar and ricochets onto the surface of the table. Prepare for this by undercoating the area around the hot spot with a light value gray made of alizarin crimson and sap green.

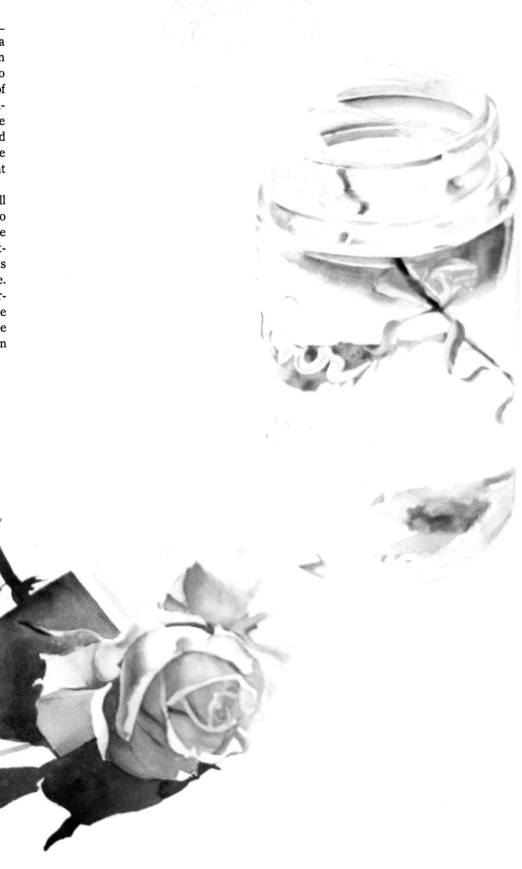

STEP SIX

Now add the light part of the rose stem, and after it has dried, finish painting the cast shadow on the right side of the rose. After I painted it, I lifted part of the dark shadow color with a thirsty brush, exposing the underpainting to interpret the bounce of light.

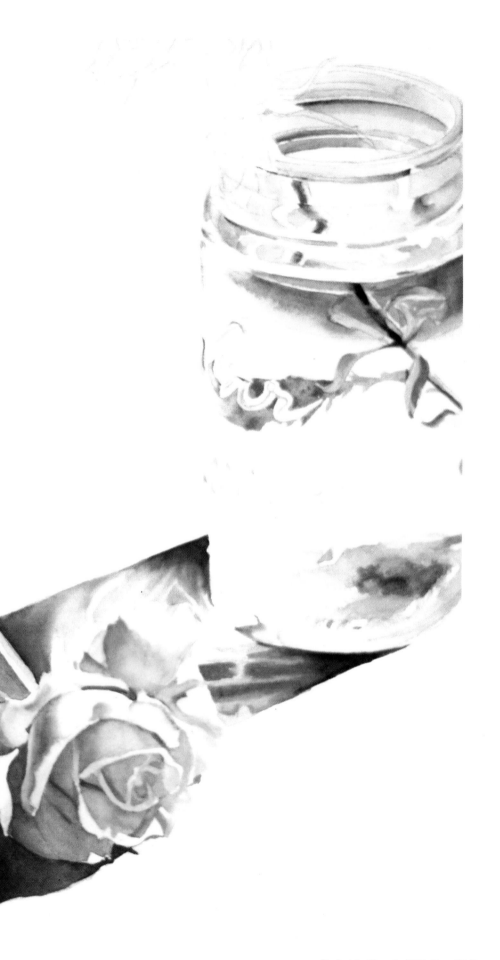

STEP SEVEN

1. Now finish the leaves on the lower rose and begin painting the rose in the jar. The trick to painting flowers in a realistic manner is to consider each petal carefully and render it observing what we know about the color of objects in sunshine.

2. I completed the painting by adding the stems and leaves of the rose in the jar. Notice that water magnifies the objects in the jar and distorts the lines of direction according to the curve of the glass.

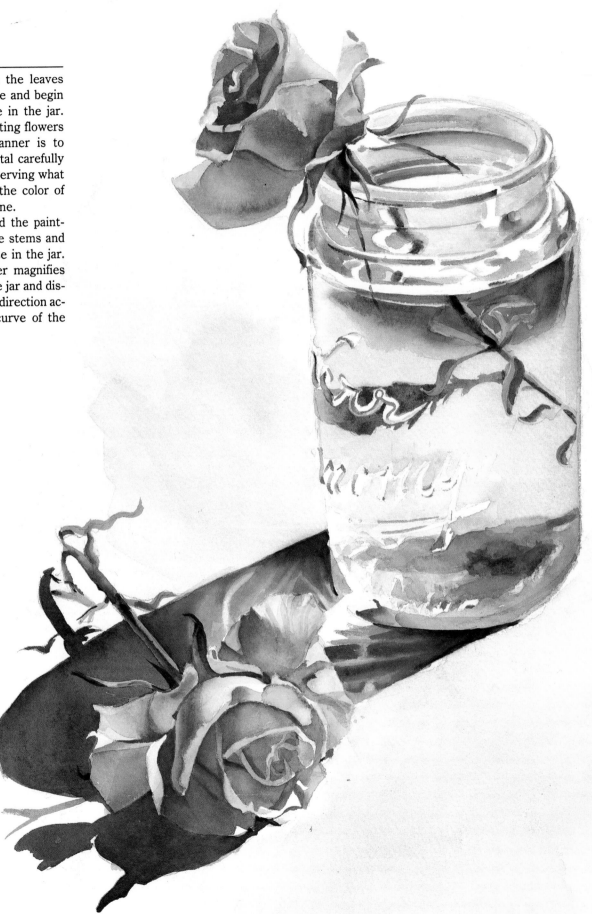

■ PROJECT 2: SILVER TEAPOT

This project focuses on painting a reflecting surface, a challenging and rewarding task. Actually, it is not as difficult as it first appears. The only "difficult" part of the process is really looking at what can be seen in the reflections. So that is the first thing I did when I began. I studied the pot carefully, squinting my eyes and looking for color. I noted that it looked warm at the bottom and cool at the top.

STEP ONE

Begin by wetting the whole pot. While it is still glistening wet, flood a light wash of raw sienna on the bottom. Wash out the brush and add cobalt blue through the middle of the pot. Again wash out the brush and add sap green at the top. Mix cobalt blue with a little raw sienna and paint the lid, remembering to keep it rather cool. Continue to work wet into wet. Your aim is to make the color darker and cooler nearer the top while keeping the bottom warmer and lighter. The neutral color in the middle is a lighter value because it is reflecting the light from above.

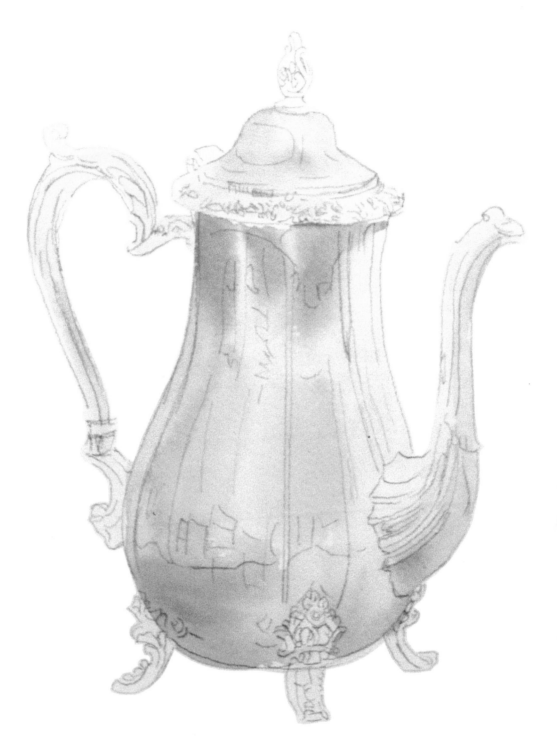

STEP TWO

Our pot is fluted, creating natural divisions which allow you to paint the body of the teapot one section at a time. Wet the section in the center with clear water and use the cobalt blue and raw sienna mixture to paint the shapes in it; then move across the pot duplicating the shapes of color and value as shown. Work steadily because it must be painted wet in wet. However, don't hurry; take care you don't let the colors seep over the edges of the fluting and take time to leave white on some of the edges between the sections. Paint the spout in a similar way and let it all dry.

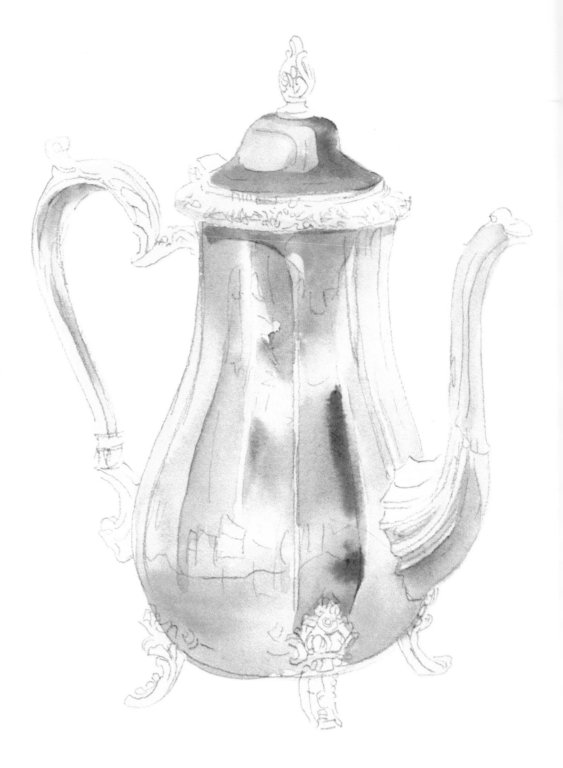

STEP THREE

1. If some colors from the previous step have merged, use dark values to redefine the shapes of the fluting. Remember this general rule: Always start with the lightest value and paint the darks over it. Work up and down around the reflected shapes of the window following the curved contours of the pot. Use a cool and dark mixture of cobalt blue and raw sienna. See the touch of alizarin crimson just above the spout and in the center of the pot?

2. Add the darks to the spout and handle. When painting anything, but especially reflective surfaces, I recommend you don't think "teapot," but think of the shapes and values you can actually see.

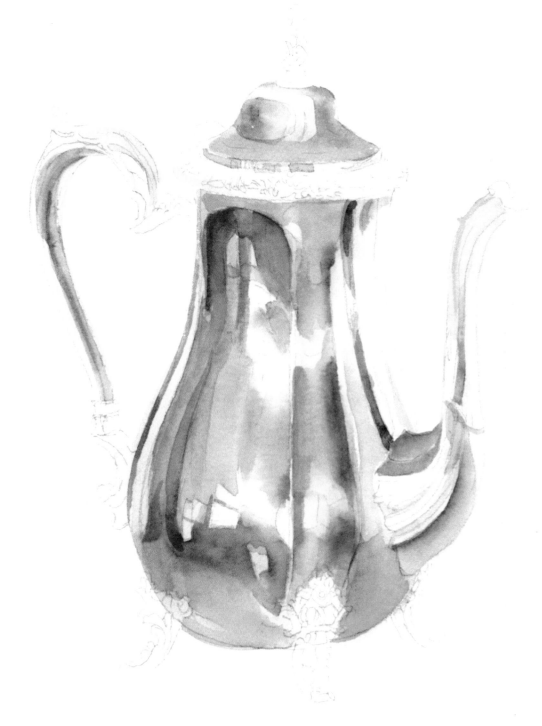

STEP FOUR

Now use clear water and wet the whole pot. Soften the edges between some of the flutes using a barely moistened flat, stiff brush. Begin painting the details on the pot, including the filigree. Underpaint the finial on the lid and the decorative rim with raw umber and Winsor blue. Use a dark value of the gray to add the flourishes on the handle. Finish the spout by adding dark accents. Do the detail on the legs.

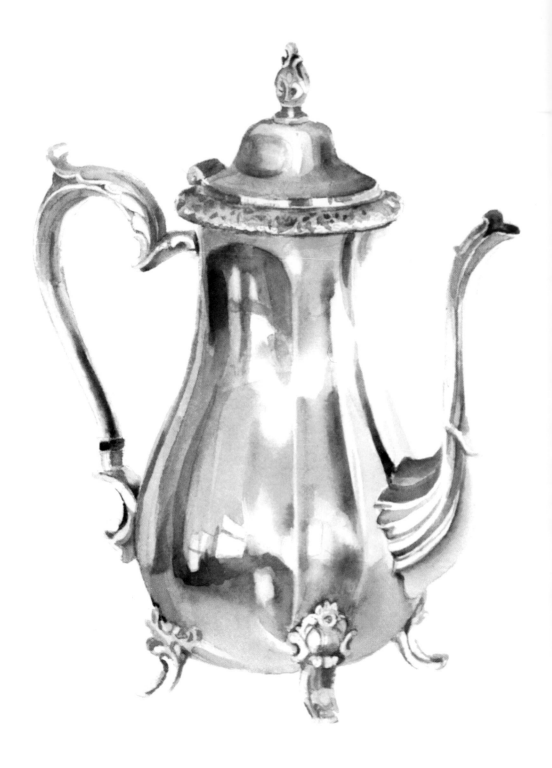

STEP FIVE

1. Finish the details. You can suggest many of the details with dots of different shapes and sizes. Add a few dark spots on the decorative pattern on the lid. Very carefully use a neutral dark value and put the "crevice darks" in the joints where the legs are fitted to the belly of the pot. Use the same dark for the opening of the spout and to settle down the handle and lid onto the pot. Add any finishing touches to what I call the "phony baloney" on the rim and finial.

2. You can make any adjustments to the values at this point. I lifted some lights with a stiff brush and an acetate frisket just under the lid (on the curved surface). After it was bone dry, I used a soft plastic eraser (Staedtler Mars or Factis) to erase the pencil lines.

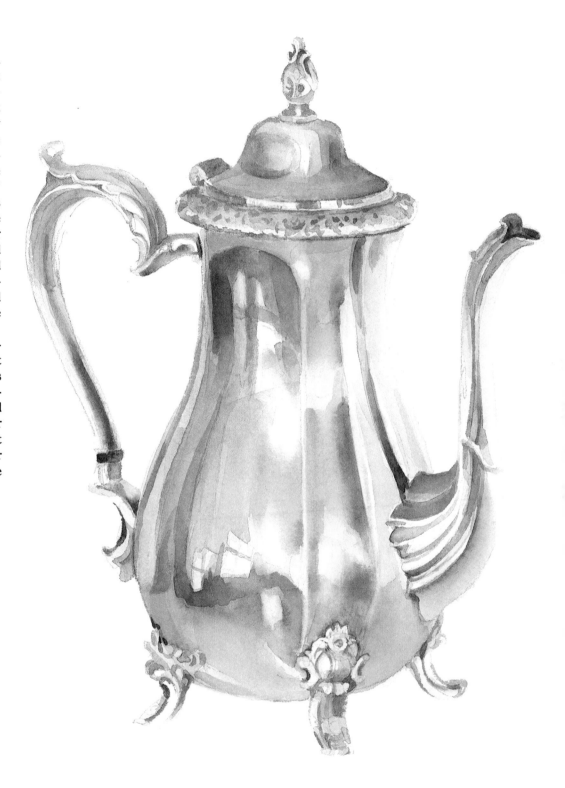

■ PROJECT 3: DRAPED DISH TOWEL

Now here is a challenge for those of us who remember getting stuck doing the dishes. Let's paint a dish towel! The real purpose of this exercise is to paint a subject that many are put off by because it seems too complicated: the folds of draped fabric. Like most complicated things, drapery is made up of a lot of little things that aren't difficult at all taken one at a time.

STEP ONE

Begin by wetting the entire towel area of the drawing with clear water. Then float in a light value cobalt blue on the top. Don't cover the entire top area, just paint a glow in the direction away from the light. Now repeat the process with a hint of new gamboge where the fabric hangs over the edge. Dry thoroughly. Wet everything once more and, using a slightly dampened brush, suggest the areas in shadow with the addition of ultramarine blue, cobalt blue and a touch of alizarin crimson.

STEP TWO

Add shadows to define the folds, building up layers of colors. Note how I used soft and hard edges to suggest how the fabric is folded. See the hard edge where the fabric folds under and a soft edge where the fabric straightens out. First add the reflected light in the shadows using new gamboge. Then begin building up the shadow areas with a cool wash of Winsor blue.

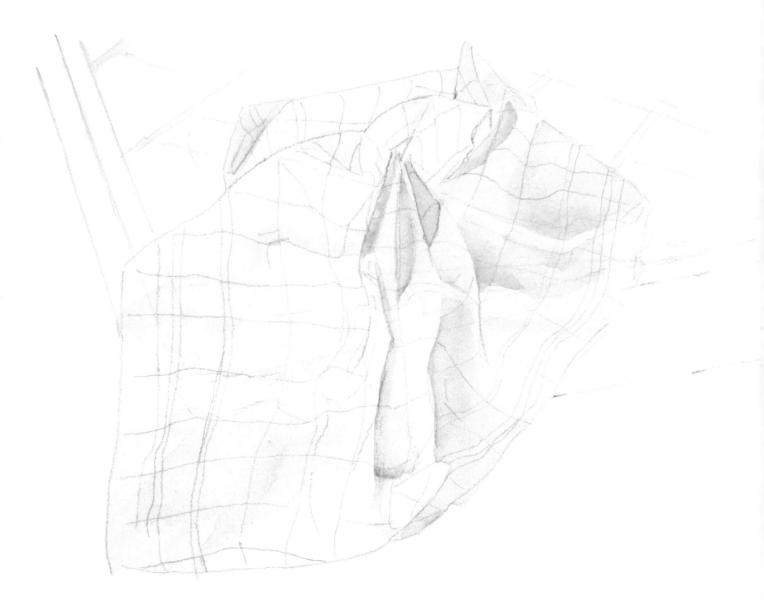

STEP THREE

Now add the dark cast shadows. Begin by painting the hard edge marking the boundary of the shadow with Winsor blue and a touch of ultramarine. Use enough water in your brush to keep a wet edge as you approach the curve in the fabric. Add new gamboge to suggest the reflected light along the edge of the fold and then back into the blue at the top of the curve. Soften this edge with a damp brush. Do not go back even if you think the yellow may not be in an ideal place. Just let the colors merge and you will be surprised how good they'll look when you are finished.

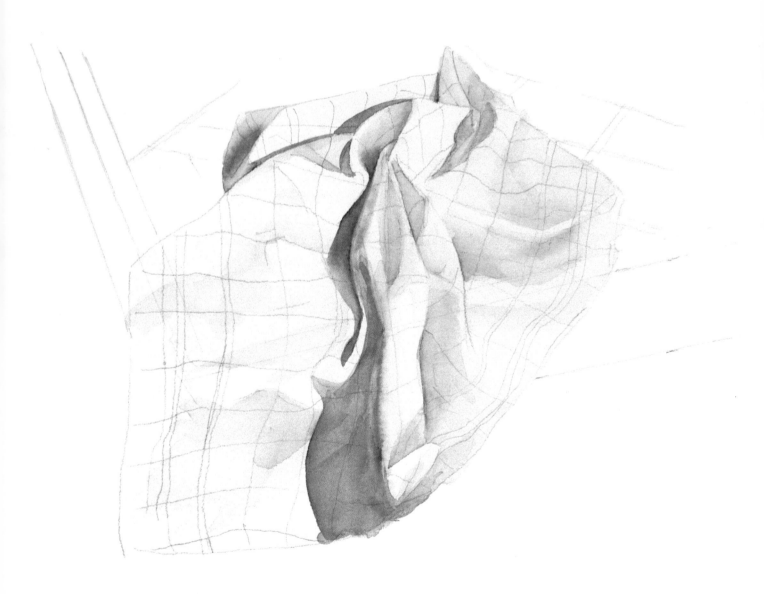

STEP FOUR

Paint the stripes next, changing their color and value as the stripes go over and under the folds. Make the colors darker and cooler in shadow to show the contours. Use a mixture of ultramarine and Winsor blue, modifying the amount of each to get just the right color temperature. Winsor blue is cooler, and ultramarine is warmer. Paint right over the shadow color that's already there.

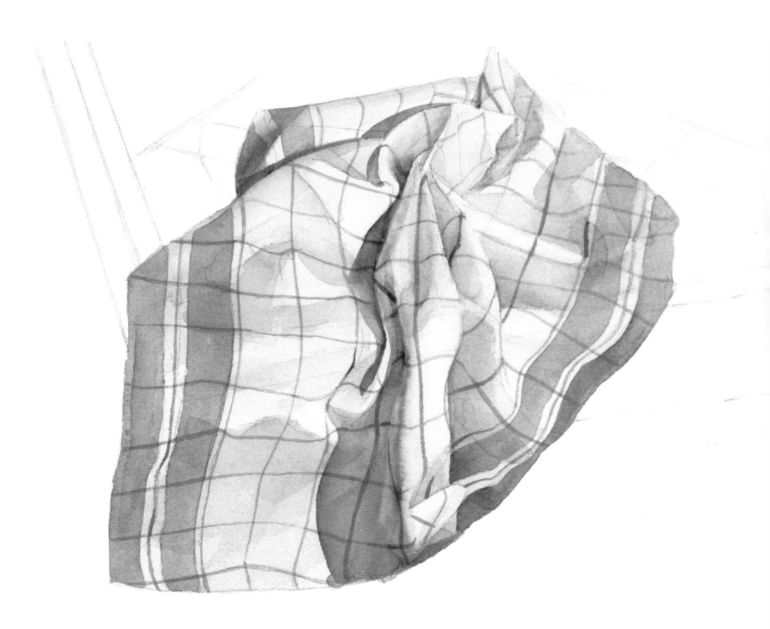

STEP FIVE

1. Add the background of the countertop using burnt sienna and a little touch of ultramarine blue to cool and neutralize it. Remember, the surfaces facing the ceiling are cooler, and the vertical ones in light are warmer.

2. Here are hints to help you get brilliant color. Always wash out your brush between additions of color. Be bold. Do not go back and try to move the color about. Let the color do its own thing.

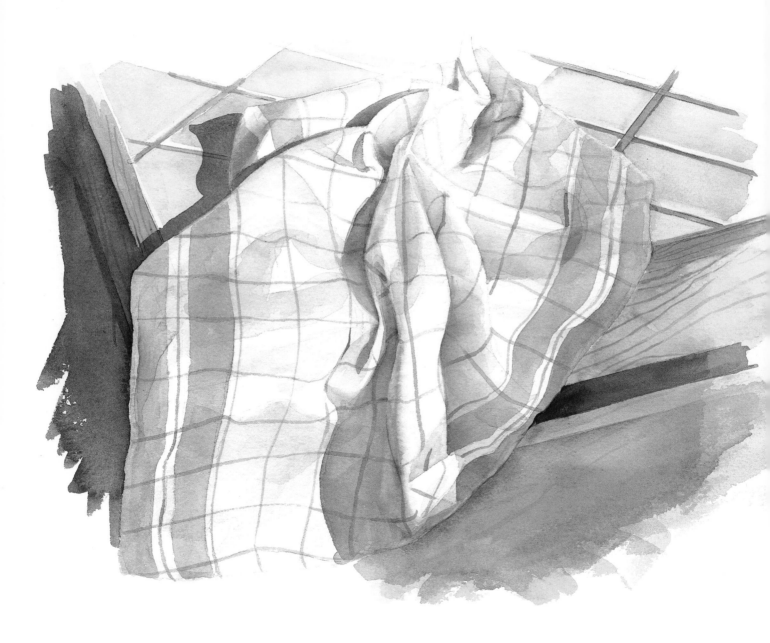

■ PROJECT 4: BASKET OF FRUIT

A basket of fruit is a perfect subject for learning how to paint still lifes. The beautiful forms of the fruit are enhanced by their rich color and provide an ideal challenge for the watercolorist.

STEP ONE

1. Begin by underpainting the basket with raw sienna. Next, use a mixture of alizarin crimson and cobalt blue to underpaint the top edge of the basket that reflects the sky. Use alizarin crimson to do the left side of the basket that is turned from the light. Let it dry. Suggest the form of the basket weave by moistening the area with water and adding darker value to the individual vertical ridges.

2. Begin painting the fruit by underpainting the yellow ones with new gamboge and the red ones with alizarin crimson. Remember to keep vertical surfaces warm and horizontal surfaces, or areas turned from the light, a cooler hue.

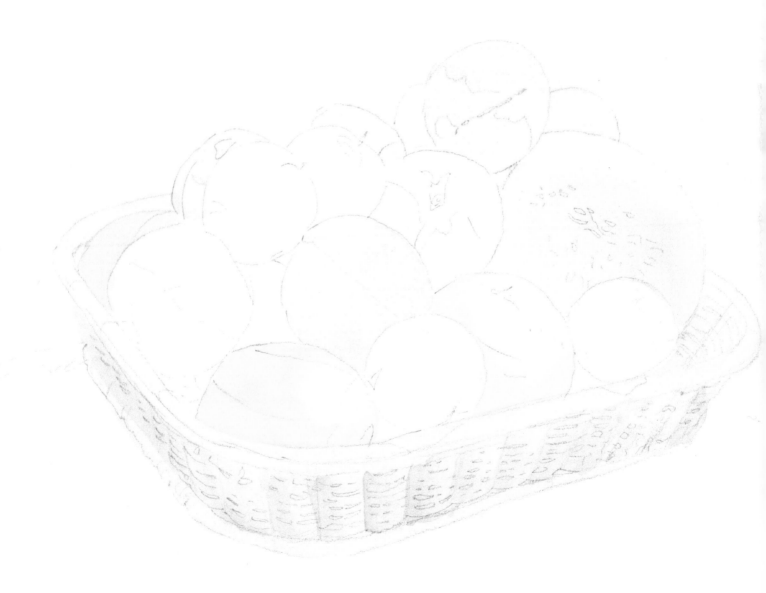

STEP TWO

I like to paint each piece of fruit one at a time, exploring the possibilities for capturing color and light as I go. You might want to put white artist's tape along the rim of the basket to protect it. Let's start with the orange in the front using new gamboge and cadmium red light to make a rich orange color. Add alizarin crimson to this mixture to slightly cool the top. The shadow area is alizarin crimson with a bit of new gamboge at the base. To create the illusion of sunlight, remember that vertical surfaces are hotter than horizontal ones. Now for the apple, plum and peach, use mixtures of alizarin crimson, cadmium red, new gamboge and raw sienna. The area in shadow should be 40 percent darker than the sunny side. You can add reflected light to the shadow side that echoes the color to be found in the adjacent fruit. Remember, *cast* shadows usually have no reflected light and are 40+ percent darker than the areas upon which they are cast.

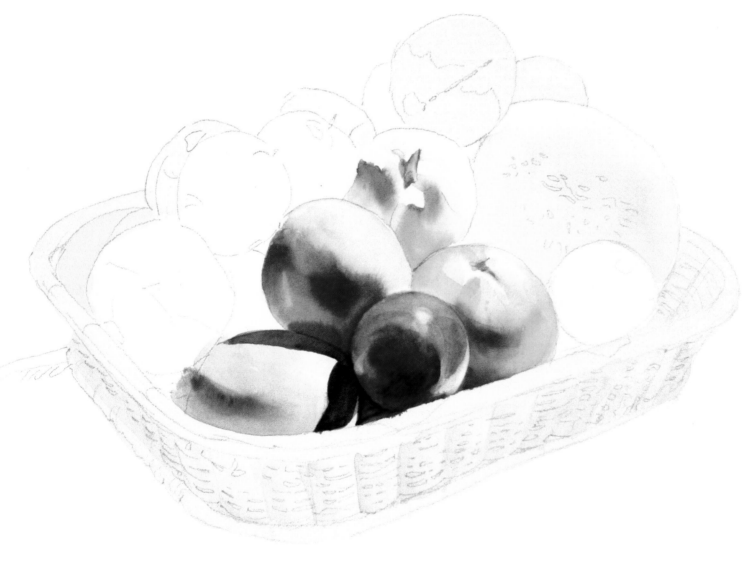

STEP THREE

Work in this manner going from fruit to fruit. First, paint the local color and let it dry thoroughly. Then add the shadow side including the reflected light color. Be careful of the edges where the sun and shadow meet on the rounded surface, and keep them soft. After the shadow side is dry, add the cast shadows. The crevice darks between the fruit are a combination of burnt umber and alizarin crimson.

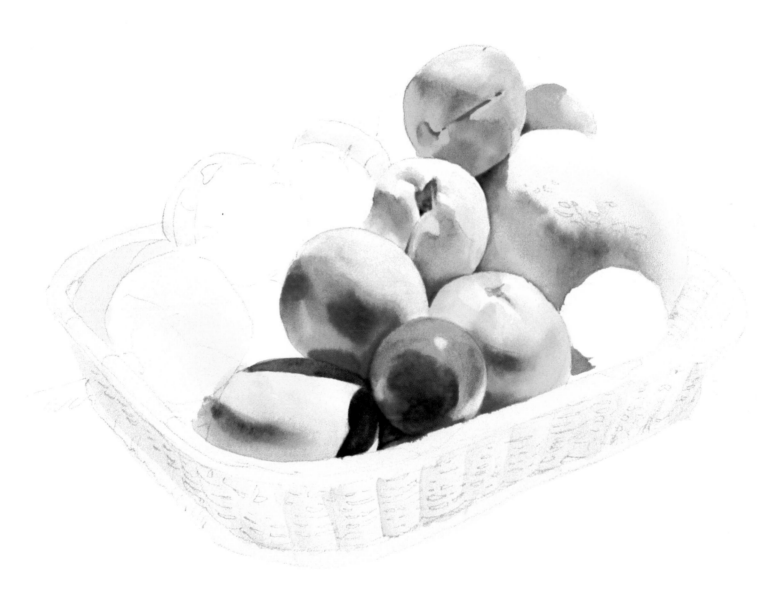

STEP FOUR

Now finish the basket. First, paint the inside of the basket with some detail suggesting an open weave by using a dark mixture of burnt sienna and alizarin crimson. Treat the body of the basket as a solid form, painting the areas turned away from the light with alizarin crimson and burnt sienna. Use a darker value of these colors on the shadow side with hints of new gamboge to suggest reflected light. Reflected light isn't very obvious until you get something dark next to it.

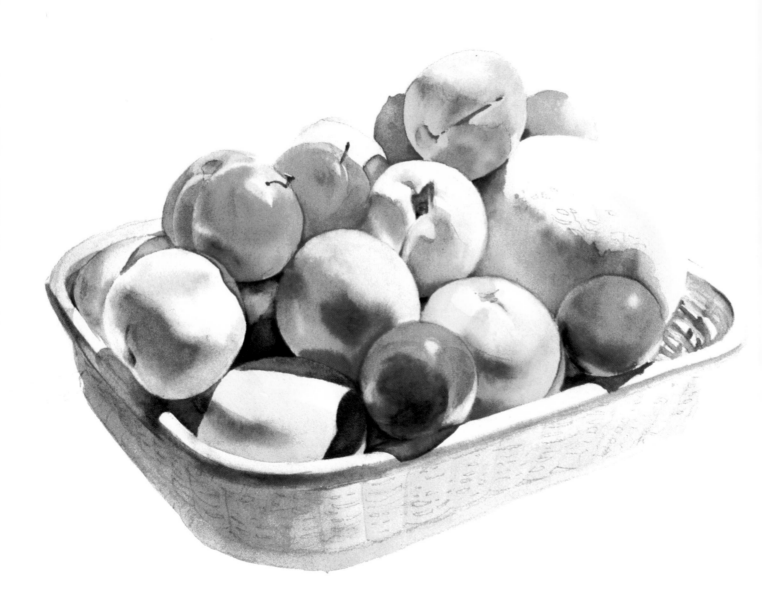

STEP FIVE

Paint the detail on the basket loosely. Begin with a very dark value mixture of alizarin crimson and burnt umber under the vertical straws. While the pigment is still wet, wash out your brush and pat out enough water to leave it moist but not really wet. Dip your brush into the wet pigment on the basket and draw the paint out horizontally to suggest the weaving.

It is not necessary to paint every detail. Paint just enough to suggest the texture of the basket.

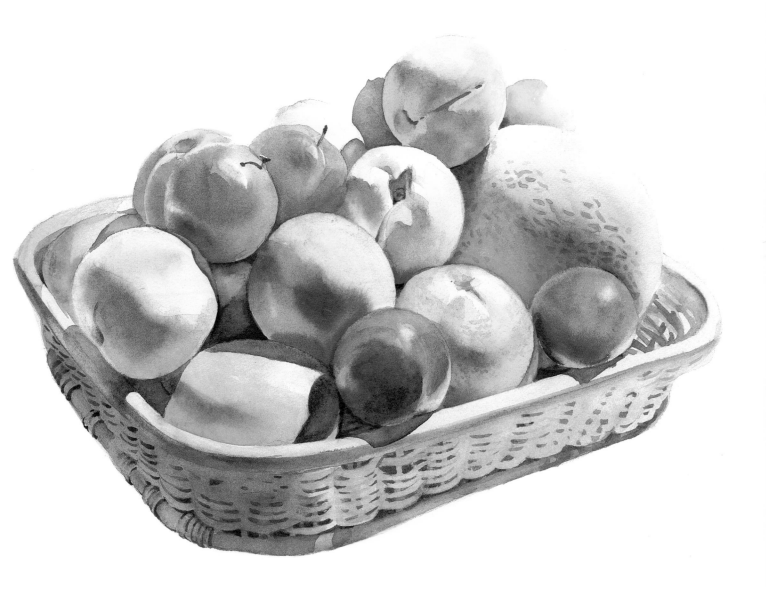

■ PROJECT 5: DOLL

Dolls make great still life objects. They come in all sizes and shapes and are so interesting you don't need anything else to make a fascinating painting.

I spent extra time preparing the preliminary drawing for this project. I knew the direction of the checks would create the illusion of roundness, so I drew them carefully. I find that the time spent planning my pictures and preparing the preliminary drawing is almost never wasted.

STEP ONE

1. The first step is to paint the base color on the face and hand with raw sienna and alizarin crimson, then let it dry. Paint around the eyes since, unlike people, dolls *do* have really white eyes! I used a small, portable hair dryer to speed the drying.

2. Next, paint the shadows and reflected light on the leg, feet and bib. By first modeling the shadow forms and then adding the stripes, it is possible to use the red and white lines to make the doll look round. Begin with the shadow on the vertical leg. First moisten the whole leg with clear water and apply new gamboge along its inner surface. Immediately add ultramarine plus a touch of cobalt blue down the center, permitting the pigments to fuse. Remember the water is already on the paper, so you don't need a lot of water in your brush. Be sure the edge of the shadow is soft to enhance the feeling of roundness. Model the folds in the dress and bib. If you feel you need more control in these areas, paint the yellow and blue onto a dry surface, let the color merge, then soften the edges with a damp brush.

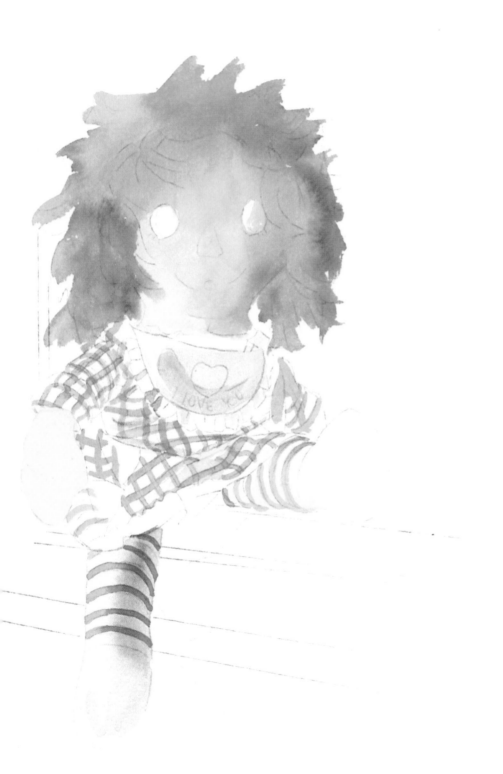

1. Once everything is dry, rewet the entire face with clear water and add a bit of new gamboge and Winsor red to the doll's left cheek to suggest the hot reflected light from her red hair. Let the pigment blend into the face color.

2. Before starting to paint the hair, it is best to let the face dry once again. After you are sure everything is thoroughly dry, dampen the inner and outer edges of the hairline to ensure soft edges. Now, work wet into wet. Lay a wet brushstroke of Winsor red into a dry orange alongside it, letting the colors blend together. Continue painting the sides of the hair in this manner, substituting alizarin crimson and Winsor red (to cool the color) as you reach the top. Permit these colors to just touch the dampened areas. If you use too much water in the hair or around it, the colors will flood out of control.

3. Now start to do the stripes. First, make sure the shadow colors are quite dry. The red should be darker and cooler away from the light, and lighter and warmer toward it. Use a little more yellow where it is facing the sun. Take your time. Paint each line carefully and patiently, following the contours to suggest form.

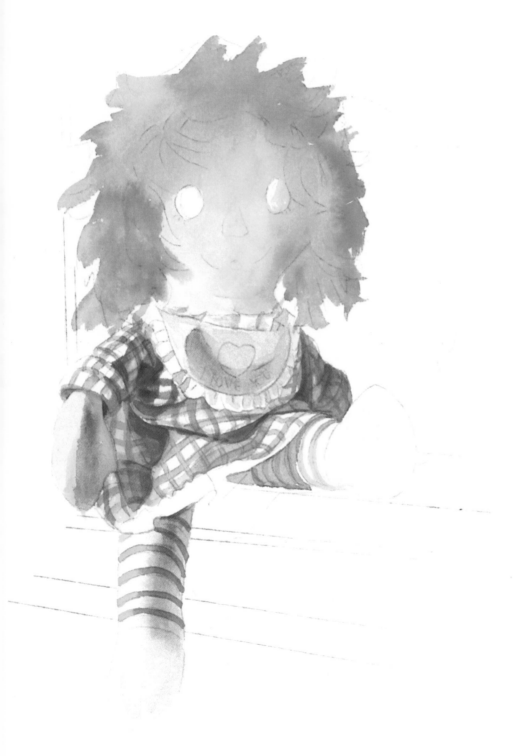

1. Now it is time to add the shadows. First add the cast shadow under the dress on the leg using a mixture of ultramarine blue with just a hint of alizarin crimson.

2. Paint the shadow on the arm by starting in the center with alizarin crimson and burnt sienna, adding new gamboge near the dress. You may find some of the red stripes are lifting as you apply these shadow colors. After everything is dry it is possible to go back and redefine the stripes wherever necessary.

3. Next, paint the shadow cast by the arm on the dress. This shadow looks red with just a touch of blue. Build the shadow color up slowly, making it darker where it folds under.

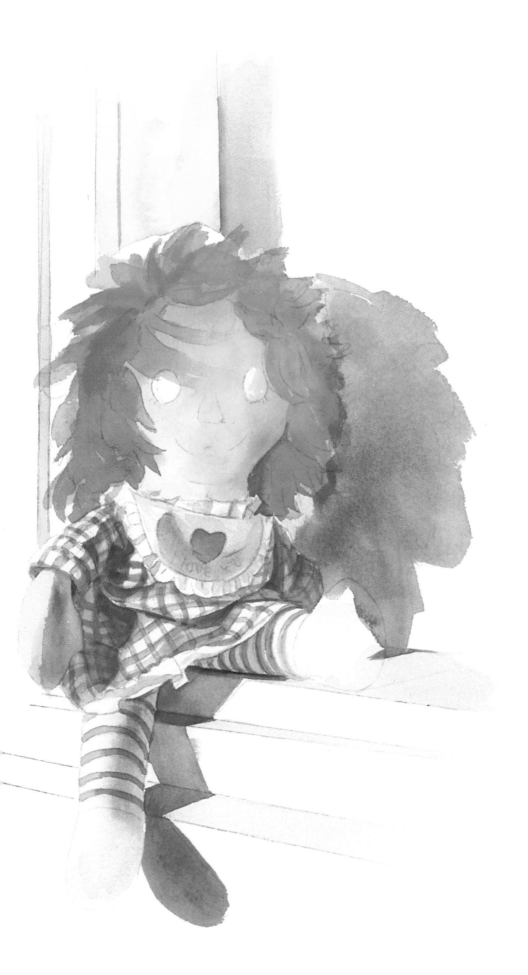

1. To paint the cast shadow on the doll's face, make a wet semicircle of color at the hairline just above the doll's right eye, then wash out your brush, dry it slightly, and pull that color across the face letting it fade out as you go.

2. Add the details on the bib. Paint the little heart and some details on the ruffles.

3. Define the cheek using a "crevice dark."

4. Now add the background. The background will really make the doll look three-dimensional.

5. Mix a combination of Winsor blue and raw sienna to paint the planes of the ledge where the doll is placed. Remember to make the horizontal surfaces cooler (more toward blue) than the vertical ones.

6. Then paint the cast shadows on the wall. I used a greenish-gray made with burnt sienna and sap green. The greenish color made a good contrast to the predominantly red colors of the doll. I added a little more burnt sienna near the foot to neutralize the gray. When painting cast shadows, "charge" in related colors to keep the space visually interesting.

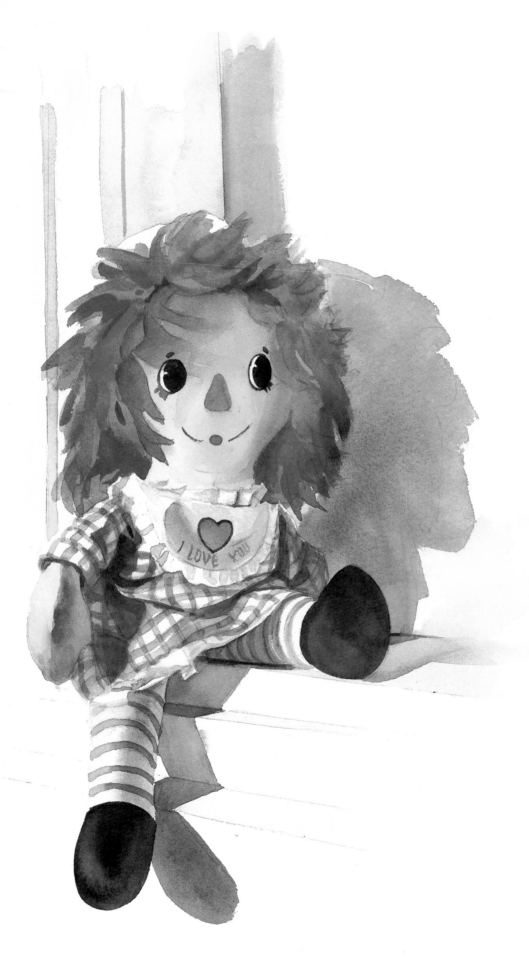

STEP FIVE

1. In the last step, add the finishing details. I am always amazed at the difference these little touches make. First, add crevice darks under the hair on the head, as well as under the legs. I added some grayed red around the hair to make it look more dimensional.

2. Add the eyes, nose and mouth. Take your time here and study my painting carefully. Outline the heart and add the words "I love you" on the bib. Don't make the lettering too dark or it will attract too much attention.

3. Color the feet with burnt umber and alizarin crimson. I floated in some sap green before it dried to keep the color lively.

4. When I was done, I looked over the painting to see if I had missed anything. I tinkered with some shadows, but I resisted the temptation to fiddle with it, an invitation to overwork a painting.

■ PROJECT 6: JARS WITH APPLES

The subject matter of this still life is apples and jars placed with a towel on the tile countertop in my kitchen. We have already painted several of these objects. Placed together they will make a nice still life since they are related in theme and have variety of form, texture and color.

STEP ONE

Begin with the underpainting. Now is the time to think about which shapes will be cool and which will be warm. Use two colors: raw sienna for the warm reflections on the jars and the fruit, and Winsor blue for the jars. Use these colors plus some alizarin crimson to paint shadows on the towel in the background. The value should be at least 4. Lay a cool wash on the foreground tile, leaving some whites for the spoon and jar lid. Remember watercolors dry lighter than they appear wet, so if the color looks correct on first application, it will probably look too light when it is dry.

STEP TWO

1. Begin with the two yellow apples in the center. They are almost completely in shadow. Paint the top (horizontal) portion with a faint glow of new gamboge. After this is completely dry begin to paint the shadows on the apples with a hot mixture of alizarin crimson, raw sienna and new gamboge. The value is darkest and the edge is harder where the shadow meets the light. Keep the pigment moving and add more sienna and new gamboge as you approach the bottom. Before this is totally dry, use a thirsty, clean brush and a quick, curving stroke to pick up the pigment where the light comes bouncing off the glass jar. Paint the warm reflections of the fruit on the jar behind them, using the same colors. This is best done by first dampening the surface of the jar and then using a fairly dry brush as you apply color. Don't worry if it doesn't go just as you intended.

2. Next, complete the shadows and define the folds on the towel using dark values of ultramarine blue, alizarin crimson and raw sienna for reflected light. The stripes come next. You might want to use a smaller brush to carefully follow the contours.

3. Underpaint the red apple with new gamboge and alizarin crimson.

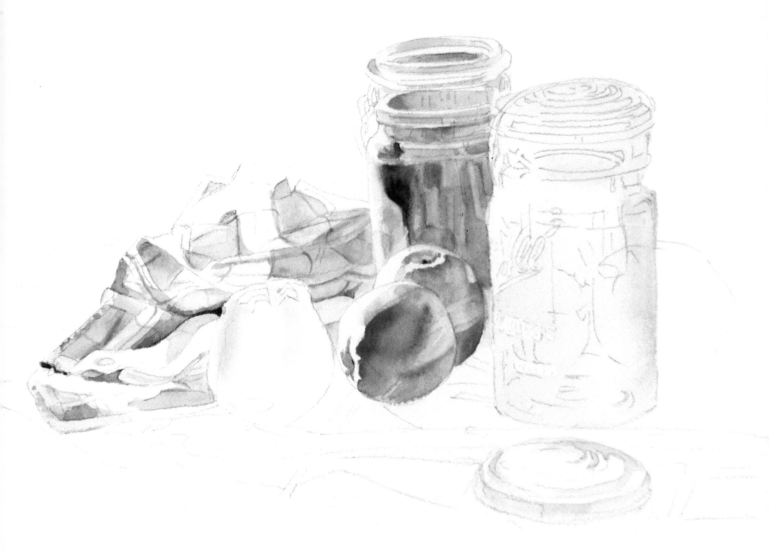

STEP THREE

1. Paint the red apples with alizarin crimson, raw sienna and cadmium orange for the reflected lights. Pick up the light highlight on the apple in front with a thirsty brush. Do this just as the glow leaves the wet surface of the still-wet paint.

2. Carefully paint the apples visible through the jar on the right. Paint around the lettering.

3. The background is blue-violet mixed from Winsor blue and alizarin crimson. Here is a case where it is best to paint a large area one section at a time. In this way you can control the edges around the jar and fruit and paint around the wire fastener.

4. Use these same colors to paint the shadows on the tile.

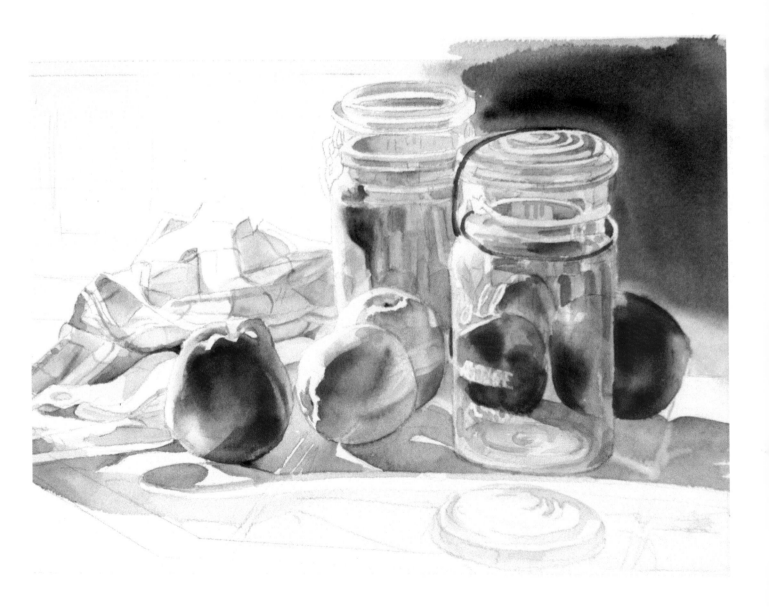

STEP FOUR

1. After everything is dry, complete the background. Wet the place where you left off with clear water, then begin in that place with the same colors. Carefully paint around the foreground objects using enough water to pull the color out and across the page.

2. Paint the spoon handle by running a wet line of new gamboge along the bottom edge and immediately adding a mixture of burnt sienna and alizarin crimson along its length, permitting the colors to flow together.

3. Paint the horizontal edge of the wooden cabinet a grayed brown. The vertical sides should be warmer.

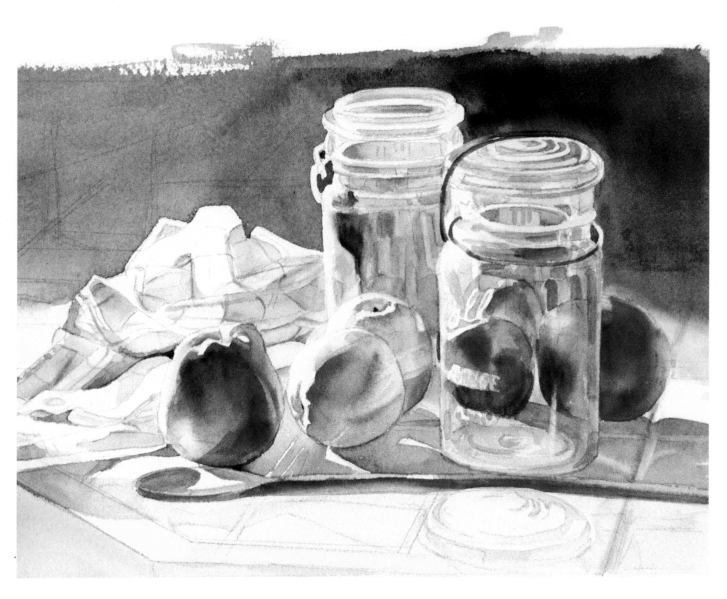

STEP FIVE

Make your final appraisal, and check the edges. I used a damp, stiff brush and white artist's tape placed along the side of the glass jars to lift white highlights along the edge and near the center to add sparkle.

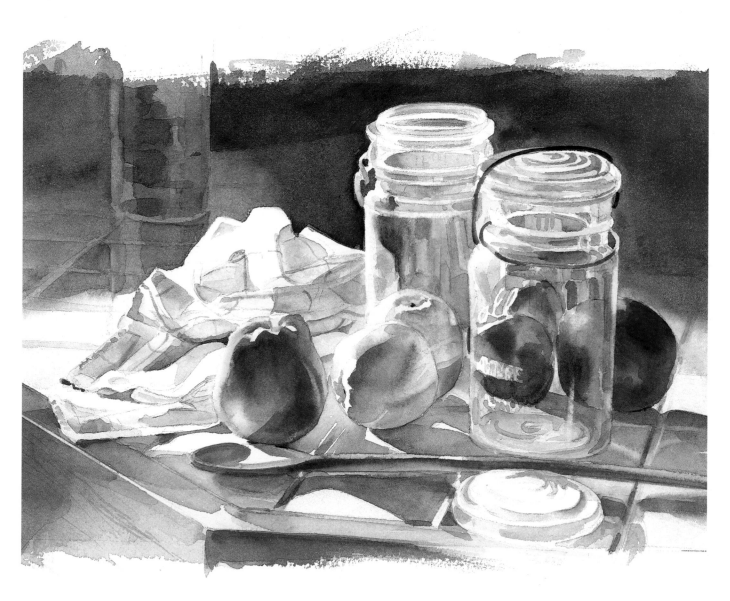

PAINTING CHILDREN'S PORTRAITS

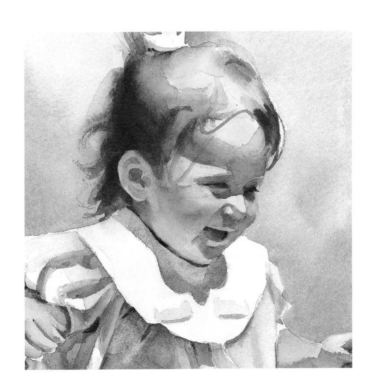

USING PHOTOGRAPHS

In portraiture there are many important advantages to working from photos. First, it is convenient. If you take a good photo of your subject, you can paint from it anytime without worrying about the light changing, the model moving or falling asleep, etc. Second, you can use the camera's viewfinder to identify a good composition from various points of view. Third, a photograph helps you make a good drawing to work from.

Caution: Never use a photograph as a crutch. Merely copying a photo will result in a dull, lifeless exercise. You must use a photograph only as a starting point.

Drawing From Your Photograph

Although the drawings are provided for you in this workbook, you should learn how to draw on your own. I will show you how to work from a photograph. As I mentioned, sometimes photographs are more convenient than working from life. This is especially true when you paint children. In this example I will work from the photograph I used for my portrait of Jonathan, the first project.

Making the Drawing

Begin with a good photograph that not only captures your subject's character, but also contains an interesting pattern of shadows. I try to avoid working from photos that are evenly lit because it makes the face look flat. If I must work from such a photo, I will try to create shadows from what I know about facial structure.

I make my drawing on pieces of tracing paper about the size of my watercolor paper. Normally I do my drawing on three sheets in three stages. The first one is the basic oval of the head and the general location of the features. Next, I overlay a clean sheet of tracing paper and develop and adjust the features to the individual model. On the third overlay I include all the information I want to have on my watercolor paper. I locate the facial planes, outline the shape of the shadows, even make any notes that I think might help. I use the three sheets because if I don't like my drawing at any one stage, I don't have to start over from the beginning, I can just go back and redo the one I don't like.

To help my students understand this process I often provide a sheet of frosted acetate to tape directly onto the photo. Next, they outline the oval of the head, taking care not to mistake the hairline for the crown, and locate the centerline on the face. The eyeballs and the wedge-shaped nose come next. After the acetate is removed, the basic shape becomes immediately apparent. In most cases, my students find it easier to construct the facial shape for their paintings from this simplified diagram than from the photo alone.

In the beginning, you may want to make tracings over your photograph as I have done here, and use them as a guide to making the final drawing on tracing paper. However, don't do this all the time, because it keeps you from really learning how to draw without using the photo as a crutch.

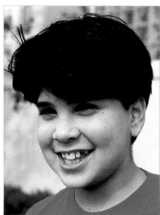

The Photograph
This is the photograph I used for the Project 7. There are no strong shadows, but there is enough shadow so that it doesn't look flat.

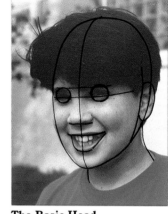

The Basic Head
Draw the basic oval shape and locate the general placement of the features on the first sheet of tracing paper. Then place another sheet on top to do the next step.

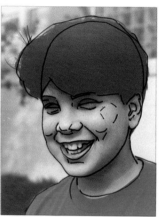

Develop the Features
Carefully develop the features. Don't be lazy and skip the first step; it is much easier to get the features right on the simple oval shape.

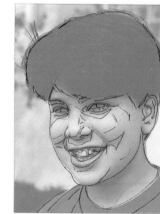

The Final Drawing
On the third sheet of tracing paper, I develop the final drawing. I complete the individualization of the features and indicate the outlines of the shadows.

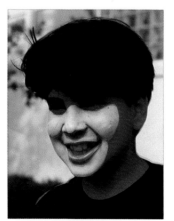

The Shadow Pattern
Look for the large pattern of lights and darks. Here, an orange overlay shows this pattern over the photo.

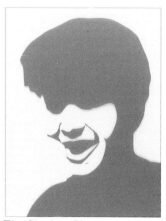

The Shadow Shape
Here is the basic shape of the shadow by itself.

■ PROJECT 7: JONATHAN

For this first project I decided to paint just a head. Because the face and head are the most essential elements of a portrait, I thought it would be a good idea to elminate other distracting elements at this point so we can concentrate on the basics. This is from the picture I used on page 37 to show you how to make a drawing from your own photograph. Jonathan is a bright eleven-year-old with a good sense of humor and a somewhat mischievous gleam in his eye.

STEP ONE

1. First, mix new gamboge and alizarin crimson and paint the entire face, including teeth and eyeballs. Even though you want the eyes and teeth to appear white, they are usually in shadow and are almost never white. To paint around them is to ask for trouble.

2. Carry the color into the hairline and down the neck. Try to keep the value of this wash light (about 2). After everything is thoroughly dry, determine the value of the skin color.

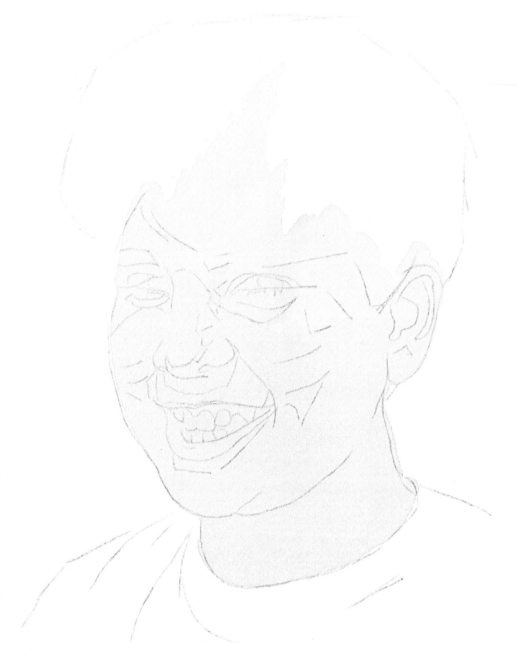

STEP TWO

1. Mix a somewhat rosy puddle of burnt sienna and alizarin crimson on your palette. Check to see that when the mixture is dry the value is 40 percent darker than the initial skin color. Be ready to add a light touch of ultramarine blue to the alizarin mixture (making a blue violet) for the cooler areas around the eyes and forehead. Now mix another puddle of yellow-green (sap green plus new gamboge).

2. Start on the left side with the violet color and paint the shadow over the eye. Wash out the brush and pull the color over the nose into the other eye. Float some of the green mixture into the temples. Don't worry if it floods back into the eye. Pull that color out into the forehead and down the cheek. Add alizarin crimson and burnt sienna while it is still wet, and continue spreading the color down under the chin. Add cobalt blue at the bottom of the chin to suggest reflected blue from the shirt. Keep it all wet and keep the paint coming.

3. Carefully paint the tip of the nose and right into the cast shadow with the alizarin mixture. Immediately add a drop of new gamboge into the wet pigment at the nostrils. Soften the top edge.

4. While all this is drying, paint a base coat on the shirt with ultramarine blue, adding a touch of yellow in front for sunlight.

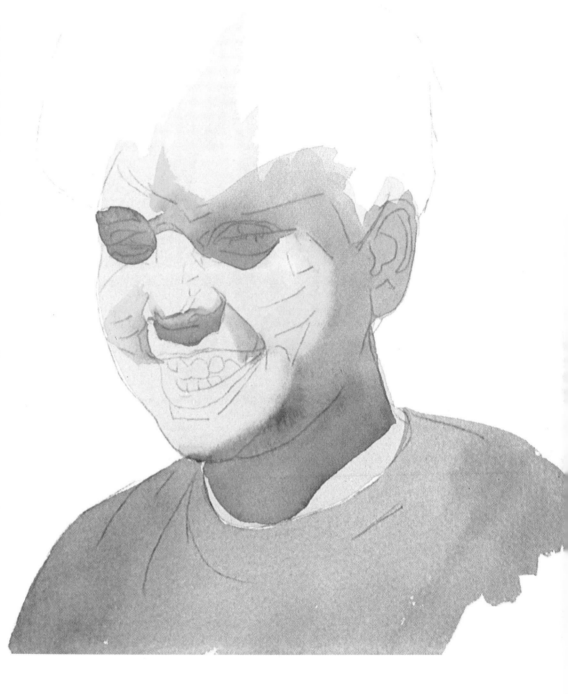

STEP THREE

1. Now model the areas of the face that are in shadow. The light indications of the planes of the head and face on your drawing are useful in this step. First do his right eye. Use a light wash of alizarin crimson and ultramarine blue and paint the shadow under the lid. Then use the same color on his left cheek and pull it into the shadow along the chin. Model the left side of the nose. Now paint one cheek at a time by first moistening the area and using a wet brush and a bit of cadmium red on the tip. Let it dry to a soft edge.

2. Paint the upper lip and bring some of the color down to define the gum line. Avoid making a dark line around or under the teeth. Use the same color to paint the bottom of the cheek. Using a dark value of alizarin, burnt sienna and ultramarine, model under the eye, the cast shadow under the lip, and the detailing in the ear.

3. Finally, suggest the fold in the skirt by adding a darker value of the blue.

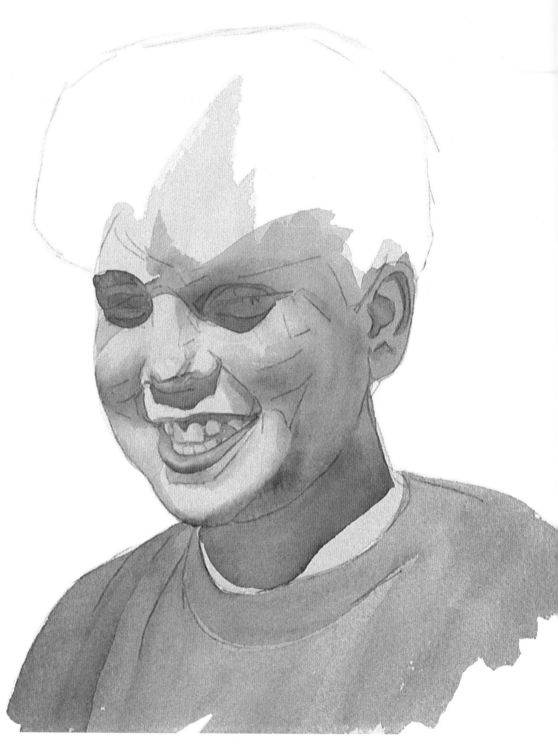

STEP FOUR

1. Start with the hair. First, wet the top of the head. The top of the head has to be cool because it is reflecting the blue of the sky. Use Winsor blue, Payne's gray, and a touch of burnt sienna. Add green for the area toward the sunlight. The brushstrokes for the hair should follow the general direction of hair growth. Paint with a wet-in-wet technique. Keep the edge along the face soft.

2. Add a dark (alizarin crimson and burnt umber) in the corners of the mouth. Use a clean wet brush to pull the two sides together, making the sides darker than the middle. Use the same colors and darken the inside of the nostrils.

3. To do the eyebrows, first moisten the area, then use a very dark mix of Payne's gray and blue to add color to the darkest place, and let it spread.

4. For the eyeball, darken the iris and pull a little dark around the edge of the lids.

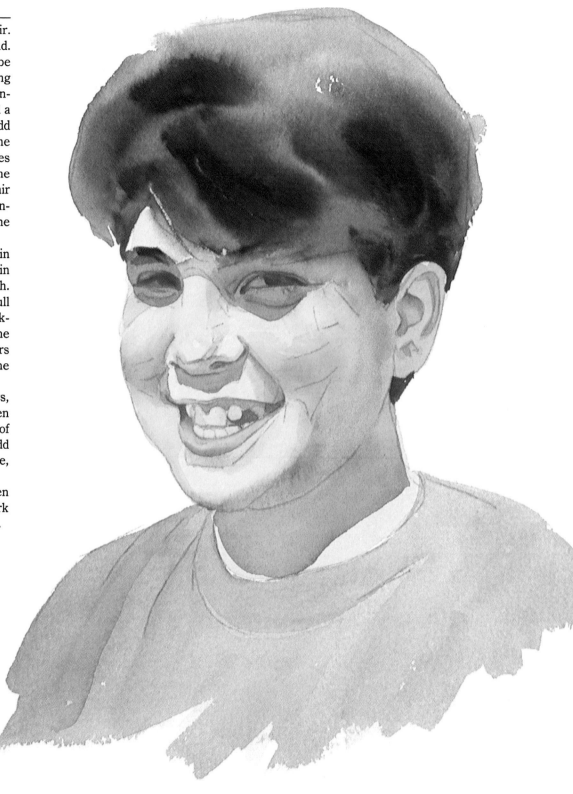

STEP FIVE

1. Make sure your paper is bone dry and erase the pencil lines. I softened the edges of the eyes by taking an oil brush and clean water and scrubbing the edges lightly.

2. I also used a crevice dark to darken the ear, and added crevice darks around the collar. If it seems to need it, glaze some violet to darken the neck under the chin.

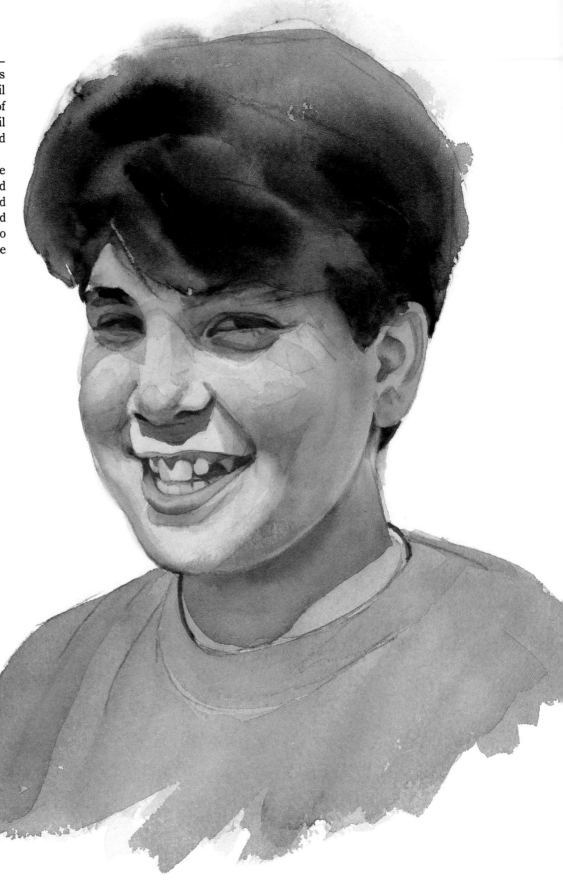

■ PROJECT 8: RUNNING TODDLER

To paint a lifelike portrait of a toddler is to paint motion. I caught little red-haired Megan in midstep. Because movement is so much a part of the character of these little ones, I like to include the whole body in the portrait. When you make a drawing from your own photograph of a baby or toddler, be sure you look carefully at the proportions. The head is much bigger relative to the body than an adult head.

STEP ONE

Because Megan is a little redhead, you want to keep the flesh tones warm so she doesn't look ill. Instead of using alizarin crimson, a cool red, as one of the basic colors in the flesh tone mixtures, use Winsor or cadmium red and new gamboge.

1. First, wash in a light wash of Winsor red and new gamboge and paint all the skin. Extend the color well beyond the hairline so the hair will not look pasted on later. Paint right over the lips and other details. Let it dry.

2. Paint the dress. Since it is a white dress, paint the shadows, leaving the white of the paper for the fabric in sunlight. Since reflected light can be any color, you will be using a number of colors in the shadows to show reflected light. This will also keep the shadow color from being flat from one side to the other, which is boring. Remember that cast shadows, such as the shadow cast by Megan's chin, are going to be slightly darker than the rest of the shadows. Begin with a wash of cobalt blue of a value of 4 or 5 as a basic shadow color and add rose madder,

new gamboge, and ultramarine blue to enliven the color as you work across the dress. Watch the edges carefully because they suggest folds in the cloth. Let it dry.

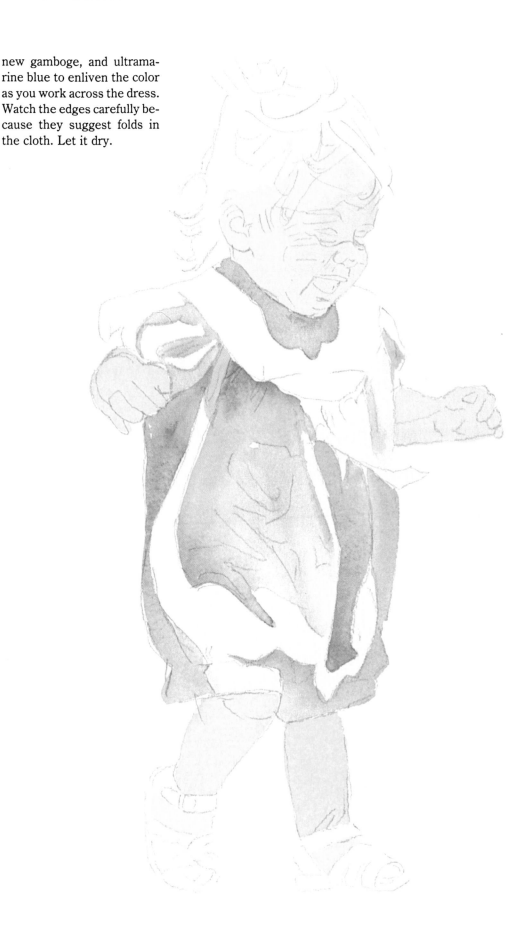

STEP TWO

1. On the shadow side of the face, wash in the dark shapes around the eyes and forehead, keeping the shapes large and simple. Mix a warm violet from Winsor blue and rose madder for the shadow across the forehead and down into both eyes. Add a little more blue into your shadow color at the bottom and add more warm color as you work upward.

2. Use new gamboge along the jawline and flood in a mixture of burnt sienna and alizarin crimson working up into the nose, across the cheeks and into the hairline. The trick is to use enough water on your painting so it remains wet enough while you work to complete an area yet allows you to go on to the next area of color and value without a hard line forming.

3. Do the basic hair color because it is still very light in value. Make it very colorful. Since she is such a cute little carrot-top I used cadmium orange as the base color and added new gamboge for the reflected lights and burnt sienna floated into it. Make a shadow color of cobalt and alizarin, and float the color into the still-wet hair, letting the colors mix on the paper. Keep the edges soft.

4. Paint the arms, hands and eyes the same way.

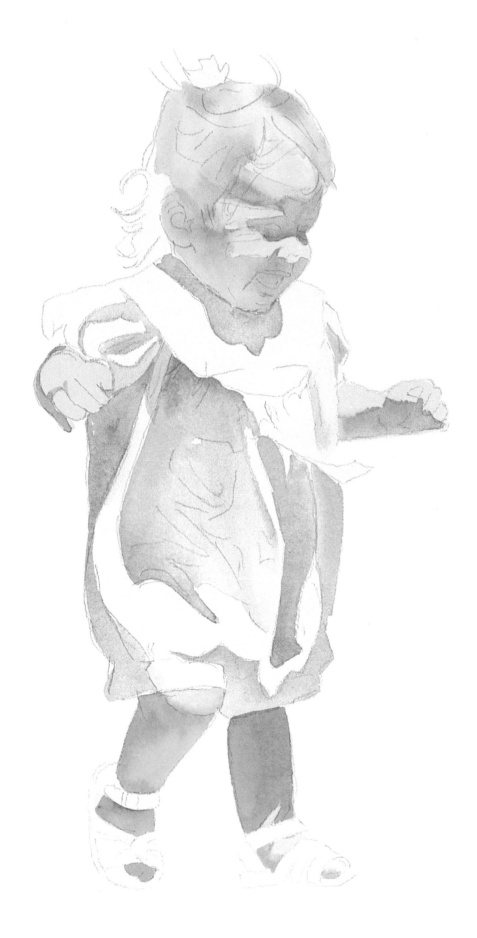

STEP THREE

1. Rewet the hair so the edges will remain soft. Use alizarin crimson and burnt sienna to work around the head to build up the shadow on the head. Paint the shadow under the ear by adding some burnt umber and alizarin. Pull some of the color into the neck and darken under the chin.

2. It is important to make your brush go in the direction of the object you're painting and to make your brushwork confident—a confident stroke looks better even if it is wrong.

3. Paint the nose making the base yellow with alizarin crimson at the top. Use burnt sienna and alizarin crimson for the dark of the mouth and details in the ear, underneath the eyes, and to define the edge of the nose. Remember, warm colors are used for any place where light can't get.

4. Let it dry. Now flood some water over the cheeks and add cadmium red into the center. Move the pigment about with the tip of an almost dry brush into position to describe Megan's rosy cheeks.

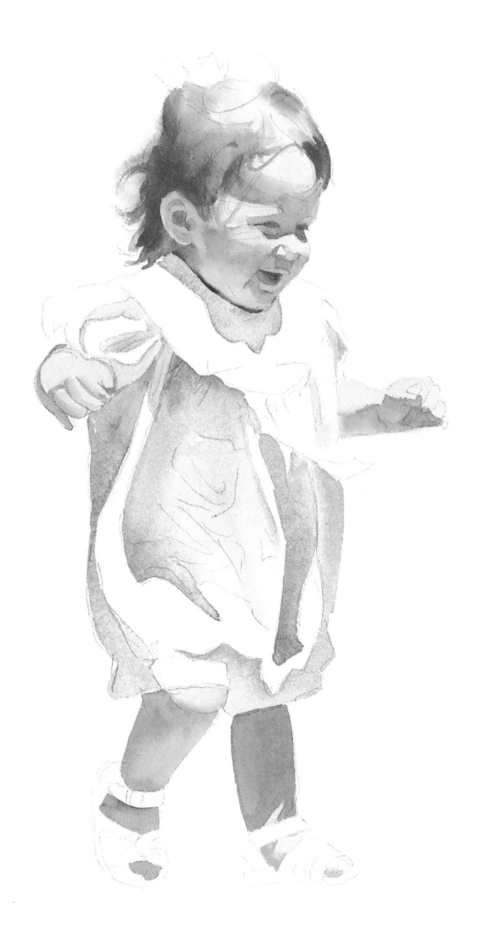

STEP FOUR

1. Darks are built up in layers. Paint the darks in the dress and model them with warm and cool variations of cobalt blue and alizarin crimson. Paint the bow on her collar and the shadow beneath it.

2. Make the ribbon look as if it is curling up by using rose madder and new gamboge to make it dark right on the edges and adding reflected light where it starts to turn. Leave a white keyline on the edge and drop in color for the reflected light.

3. Paint the shadow side of her shoes with a value 5 mixture of burnt sienna and ultramarine. The sole of the shoe is burnt umber and alizarin crimson.

4. Add the crevice darks to define the edge of the cuff on her bloomers.

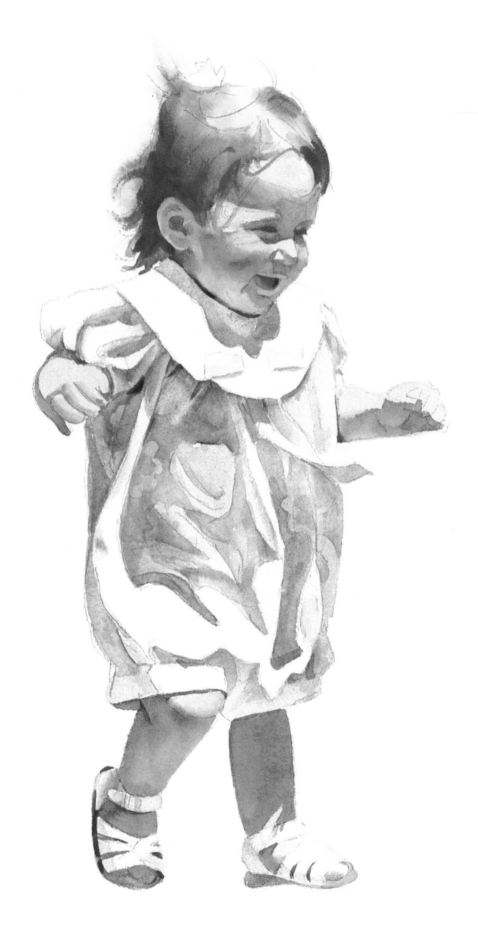

STEP FIVE

Add some yellow in the eyebrows for reflected light. Use a cobalt wash around the edge of the collar to define it more clearly. As a final touch, add the background color using a complementary gray-green made of sap green and burnt sienna. Add the warm dark on the bottom while it is still wet, but keep the edges soft so it won't be too abrupt.

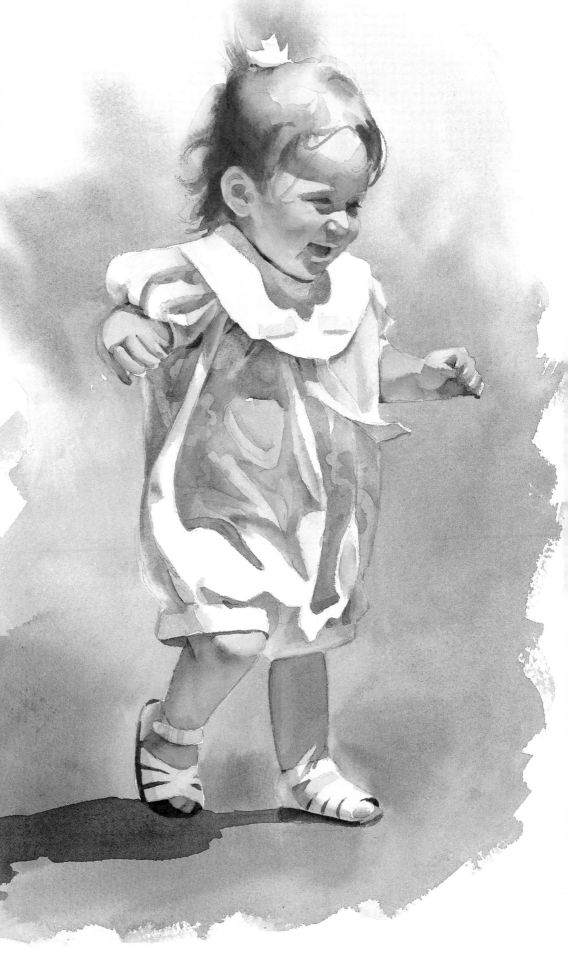

■ PROJECT 9: GIRL WITH PUPPY

Here is a warm, loving young lady. I wanted to show her with her puppy because it brought out this aspect of her character. When you paint a portrait with secondary subjects, you must be careful to integrate the secondary subject matter into the portrait so it enhances the primary subject.

The key to making your portraits glow with light is colorful shadows. In the shadow on the face, I detected a bit of green and orange and decided to emphasize those color notes in my painting. I also considered the 40 percent rule, so I made the shadow colors a full four steps darker than the areas in sunlight.

STEP ONE

1. Using a light wash of alizarin crimson and new gamboge, wash in the flesh tones on the girl's face and arms. Remember to keep this tone light. The value shouldn't be darker than 1 or 2.

2. Now do the puppy, leaving the paper white for the areas in sunlight. Use a wash of new gamboge with raw sienna. (Raw sienna is really a very cool yellow.)

3. Wash on the color of the girl's dress using Winsor red with just a little new gamboge for the areas in sunlight. For the areas in shadow, cool the color with some cobalt blue and a bit of rose madder.

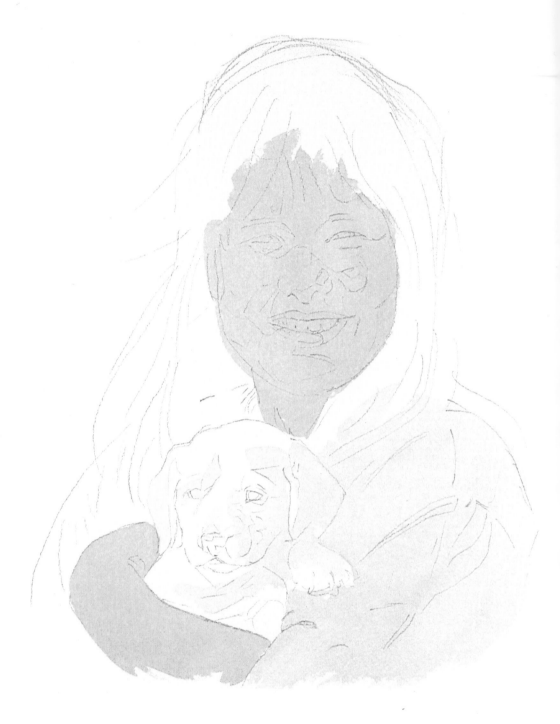

STEP TWO

Before painting the shadows, I studied my source photograph to see what colors were in the shadows.

1. Build up the shadows by laying in washes of color and adding touches of other colors to these washes while they are still wet. To get the right values, you can sometimes layer washes of color one atop the other, using a hair dryer to speed up the drying between coats. Mix the colors on the paper rather than on the palette wherever possible because it makes more brilliant colors. Be careful not to deaden the colors by layering too many colors or by canceling out a color by glazing it with a complementary color.

2. Paint the shadow shapes on the face first, using mixtures of burnt sienna and alizarin crimson as the basic color. Add hints of sap green and new gamboge to show the reflected light on the left side of her face.

3. The shadows on the dress were made from a mixture of alizarin crimson, new gamboge and ultramarine. Lay in the shapes of the shadow and soften the edges with a clean, wet brush. Next, paint the shadows on the puppy. Keep the values rather light (about 4). Use a mixture of alizarin crimson and raw sienna. The bright (see-through) spot on her sleeve was created by charging pure color into the painted area before it dried.

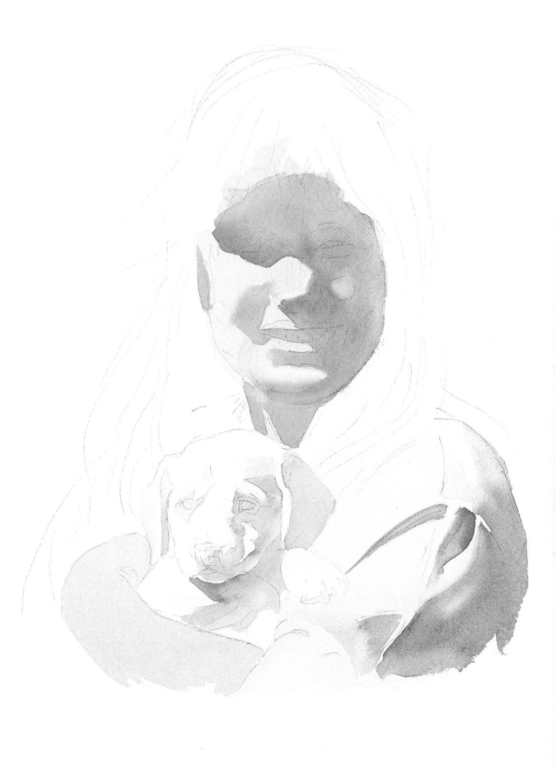

STEP THREE

1. Continue building up layers of color to model the forms on the face and hair with a mixture of alizarin crimson and new gamboge. Remember that the cast shadow will be a bit darker than the shadow side.

2. When painting hair, remember that the areas facing the sun are bright and warm. The top of the head will be cooler, and the shadow side will be a dark value of the sunny-side color. Wet the entire area on the paper that will be hair. Be careful to avoid the sunstruck place just above her bangs and begin adding pure color to her hair one stroke at a time. Follow the contours using raw sienna, new gamboge, burnt sienna, and alizarin crimson along the sides of her cheeks. The top of her head is alizarin crimson and ultramarine blue. You can add the darks now, or, if you choose, let it all dry completely and then rewet the hair and add the darks using alizarin crimson and ultramarine blue with a dash of sap green for interest. Pull some of these colors into the face to keep the edges of her hair soft.

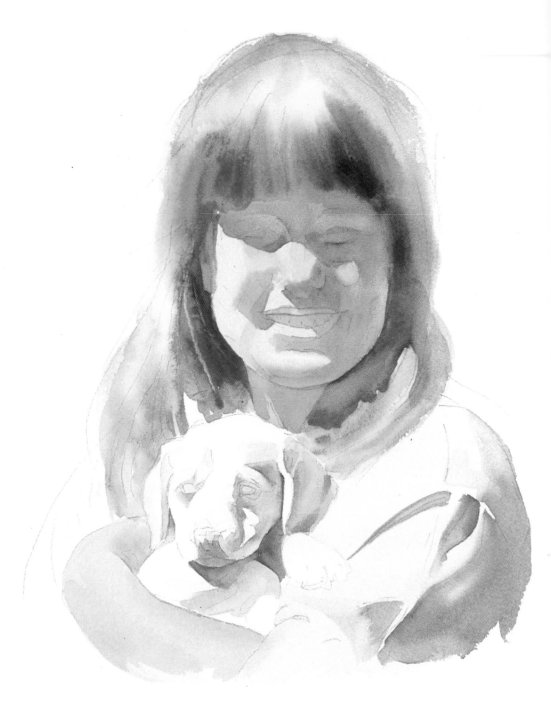

STEP FOUR

1. For the dark details make a dark with burnt umber and red violet made up of ultramarine and alizarin crimson. Add the eyebrows and eyes. Since the eyes are in shadow, the whites of the eyes are almost as dark as the iris. The teeth are in shadow, so they are dark as well. Use a crevice dark for the corners of the mouth and along the lips. I warmed up the lower lip a bit at this point with cadmium red.

2. Add the dog's facial features now, using the same dark. Remember to keep a white highlight on the dog's nose. You can use an acetate frisket and a damp short-bristled brush to scrub it out if it disappears, I added small dots on the dog's snout and scraped whiskers in with a hobby knife.

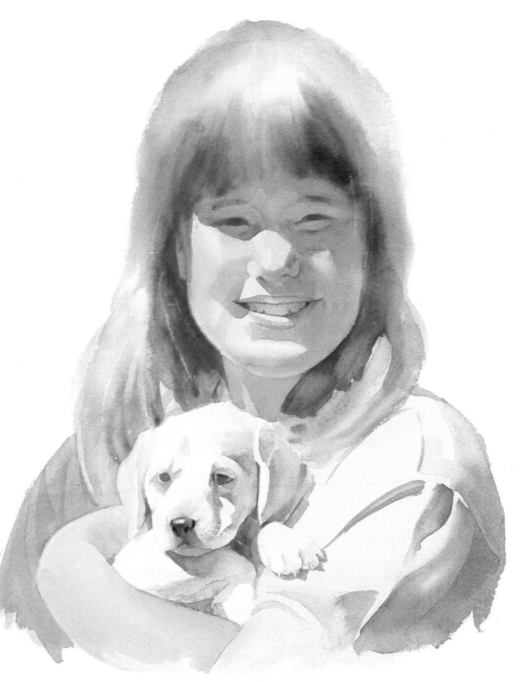

STEP FIVE

The only thing remaining is the background. To enhance the sunlit color of her hair, make the background cool. I used ultramarine and alizarin crimson. Lighten the wash near the dark side of the hair. Don't make the color too flat. Vary the value and color a bit for interest.

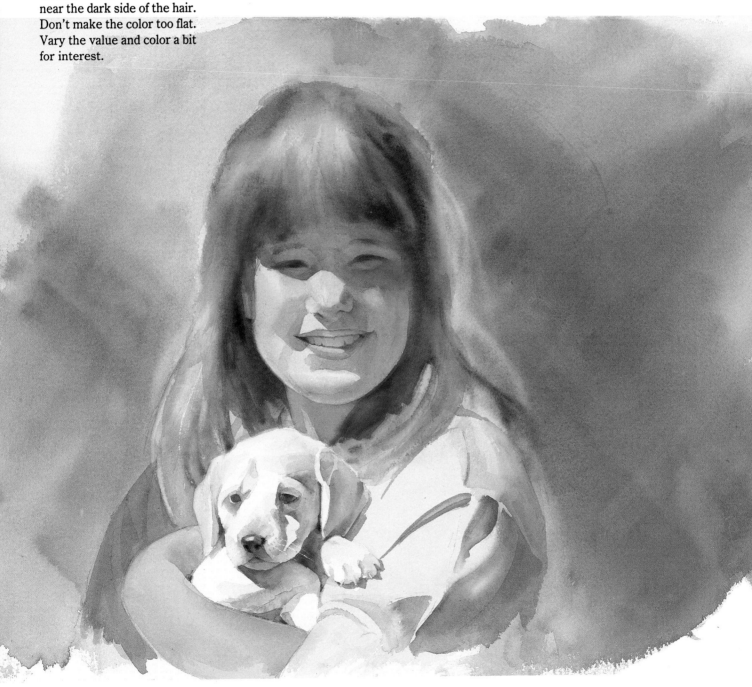

■ PROJECT 10: BOY WITH FISHING POLE

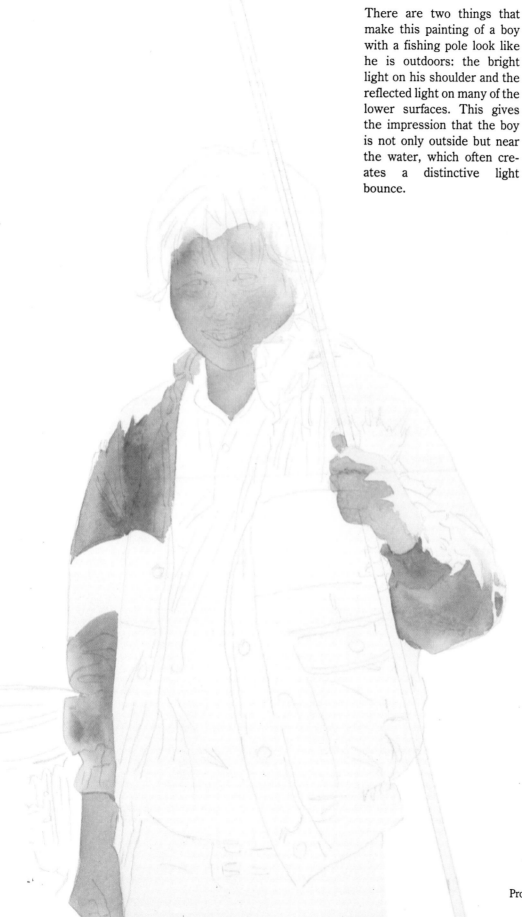

There are two things that make this painting of a boy with a fishing pole look like he is outdoors: the bright light on his shoulder and the reflected light on many of the lower surfaces. This gives the impression that the boy is not only outside but near the water, which often creates a distinctive light bounce.

STEP ONE

After carefully transferring the drawing, let's clarify what we intend to do. The sun is on our right and slightly behind this figure. The whole face is in shadow while the top of the head is bathed in sunlight. If his face were in full sun the value of the skin tone would probably be 1 or 2, so we must paint his face in shadow as dark as value 4 or 5 and add any reflected light with our first wash.

1. Mix a puddle of alizarin crimson and burnt sienna to paint the face. Lighten the areas a bit on the sunny side, and add sap green and new gamboge to the wet pigment as you approach the other cheek.

2. Wash a light skin tone on the hand holding the pole and let it dry.

3. In the meantime, paint the other hand the same value as the face. After the left hand dries, add the shadow tone, retaining a hard edge against the area in sunlight. While the pigment is still wet, use new gamboge to suggest the reflected light on the knuckles and forefinger.

4. For the body of the jacket use cobalt blue, adding yellow and a touch of rose madder for reflected light. The edges of these shadow shapes are hard. Carry these colors into the space above as they will be covered by the dark stripe of the jacket. Notice the intensity of the reflected light on the left sleeve.

STEP TWO

1. Wet the hair with clear water. While it is wet, float in burnt sienna, new gamboge, Winsor red and raw sienna. Pick up lots of pigment with the brush tip and pull the color toward the top of the head.

2. Begin modeling the facial planes with these same colors plus alizarin crimson.

3. Continue painting the jacket. Start under his right arm with new gamboge, rose madder and cobalt blue applied separately and allowed to mix on the paper. Keep the look cool. The color on the other side of the zipper should be more blue, but do add flecks of the other colors to keep it interesting.

4. Model the fingers on his left hand with burnt sienna and alizarin crimson plus burnt umber in the darkest areas.

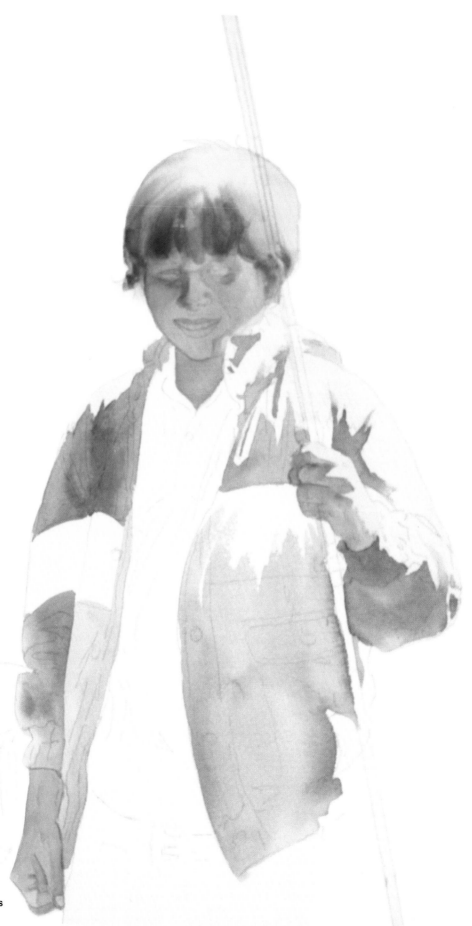

STEP THREE

Paint the T-shirt with a purple made up of alizarin crimson and ultramarine blue. Try to mix these colors on the paper. The folds in the jacket are a dark blue-gray made up of Winsor blue with a touch of Payne's gray. I added wedges of pure alizarin crimson where I wanted to suggest a deep fold. Take your time manipulating the color and softening edges.

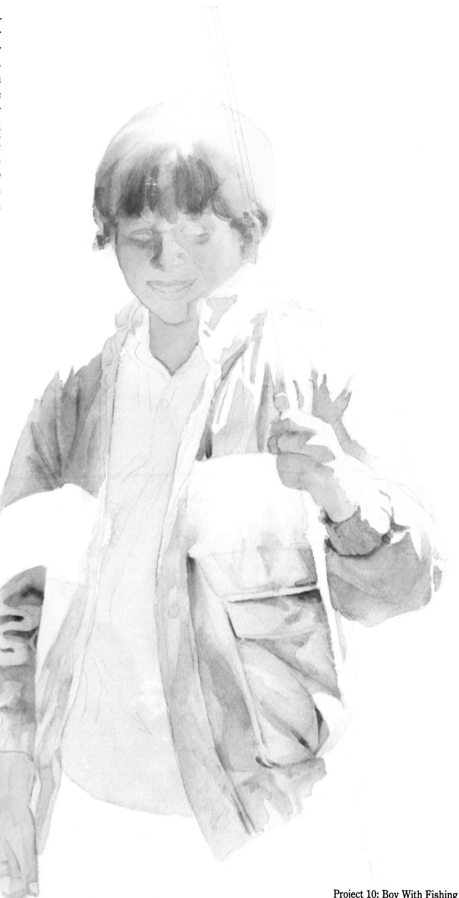

STEP FOUR

In this step you will add the folds on the T-shirt, the blue stripe, the jeans and facial detail, leaving a few finishing touches for the final step.

1. Use ultramarine blue for the jeans. The blue stripe on the jacket is Winsor blue. After the jacket is dry, use a darker value of Winsor blue plus a bit of raw umber for the folds and darker areas. Change to a blue violet under his hand.

2. The folds on his shirt are blue-violet with a touch of new gamboge and rose madder.

3. Study his face and add details to the features. Use a crevice dark for the corners of his mouth, the nostrils and the irises. I used the same dark to reinforce the folds around his collar.

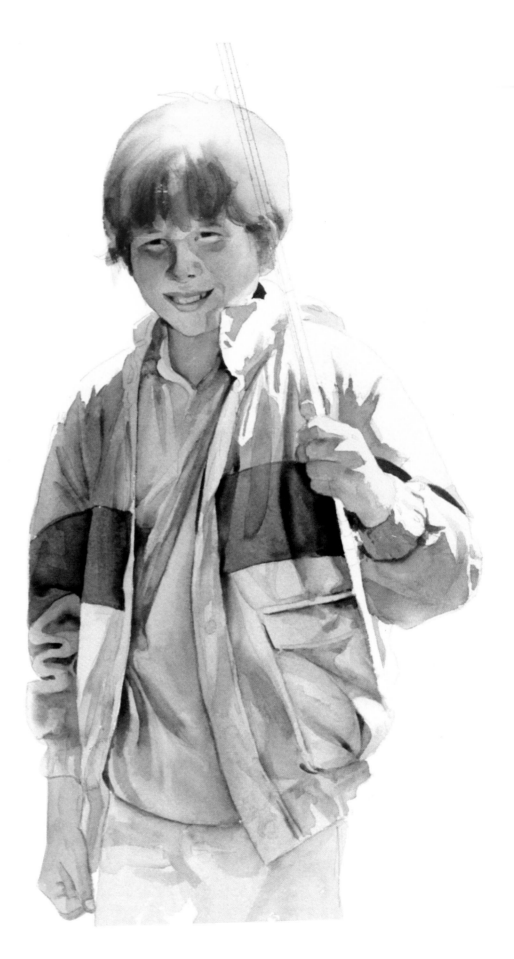

STEP FIVE

Darken the trousers using ultramarine and Payne's gray. Add the buttons and detail to this jacket. Add a light blue wash on the highlight on the jacket. Use sap green and raw sienna on the fishing pole. Survey your work and make any necessary adjustments.

■ PROJECT 11: GIRL WITH BABY

Welcoming a new baby into the family is an especially wonderful time, and certainly a worthy subject for a painting. Here are my grandchildren, Kyna and Kelly, when they first met. In this sort of a painting we should try to create a gentle mood. The colors should be warm and intimate, the edges soft and round.

STEP ONE

1. After transferring the drawing, the first step is underpainting the skin tones on the hands and faces of both children with a light wash of new gamboge and alizarin crimson. The folds in the blanket can be handled one at a time. First, moisten the area, paint a line of ultramarine blue at the top of the rounded fold, then immediately add a warmer color as the fold curves away from the light. Wash your brush out after each additional color. No hard edges here—they can be added later after all is dry.

2. If you don't get it right the first time, don't be discouraged. Getting the correct ratio of water to pigment takes practice.

STEP TWO

1. Next, add the shadow side to the faces using a rosy mixture of alizarin crimson and burnt sienna.

2. Continue to develop the folds in the blanket and along the baby's arm. Add yellow to suggest reflected light while the blue pigment is still wet. When you work wet into wet the colors may move where you don't want them to go, but do not be tempted to correct them. In the final painting you may like them exactly where they are, and you can ruin a painting by working back into an area that has already started to dry. In any case, the time to make corrections is after everything is thoroughly dry and you have a chance to analyze the problem.

STEP THREE

1. Begin to model the rounded curves in the children's faces using darker mixtures of alizarin crimson and burnt sienna. When this color appears too hot, switch to a warm violet. The cast shadows have hard edges. Begin next to the baby's hand and use a dark value ultramarine blue plus alizarin crimson to suggest the cast shadow. Draw that color out with clear water and continue up the blanket and across the little girl's face. Repeat this process where the shadow falls across the baby's hand. Go slowly and pay attention to the dark and light places within the shadows themselves. Be careful not to get so much water on your brush that you lose control, or so little water that the brushstrokes are visible and jagged.

2. Add the darks around the fingers and use a crevice dark of alizarin crimson and burnt umber to tuck the baby's head down into the blanket. Next, use a cool blue violet to model around the eyes of both children.

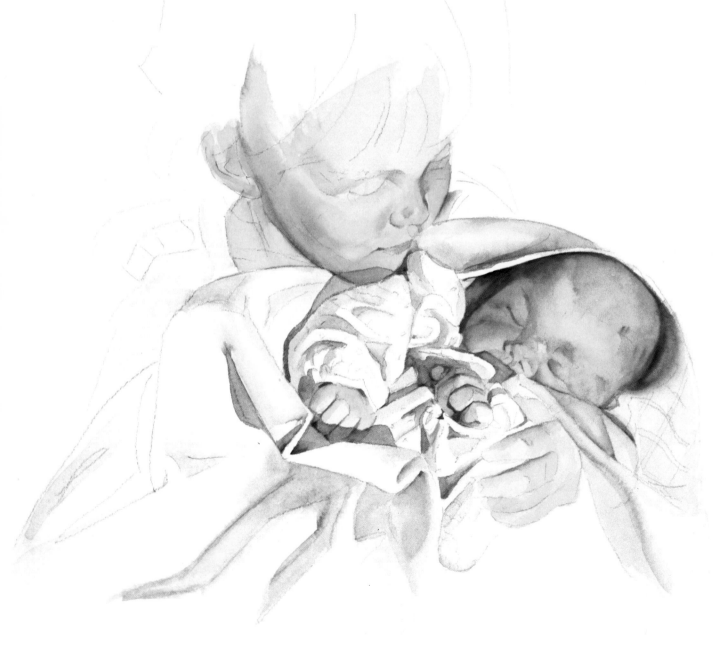

STEP FOUR

1. When painting hair, the trick is to wet the area first, put pure color into your brush, and paint one brushstroke at a time following the contours of the head. Let the colors touch and mingle on the paper. Don't go back, and don't mix color in the palette. Remember, most of the water you need is already on the paper. The colors I used are burnt sienna, raw sienna, alizarin crimson and ultramarine blue.

2. The eyebrows and eyelashes are treated much the same way as the hair only with less water. Dampen the place where you want them to appear, then touch your color to the place which appears darkest. Let the water carry the brow or lash softly the rest of the way. If you need more water, gently pull the color across with a clean dampened brush.

3. Finally, use new gamboge and blue to do the stripes on the blanket, carefully following the contours.

4. You can underpaint a background color at this time. I used a light blue-violet to define the edges of the blanket and then painted that color into the edges of the hair on the older child.

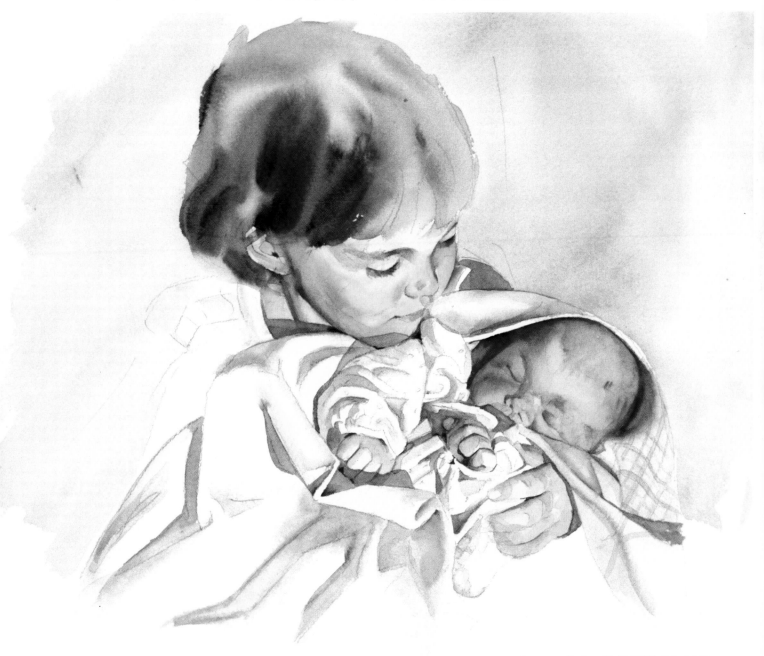

STEP FIVE

Now assess your painting and make any adjustments necessary. Do you need to soften an edge or warm a recessed area?

To enhance the feeling of intimacy, the background should seem to surround and caress the figures. Notice I left the background light behind the older child's face, and then tried to lose her hair into the background color.

■ PROJECT 12: A GROUP PORTRAIT

It is often the gesture or stance that identifies a person when viewed from a distance. In this portrait we must capture these special characteristics plus confront the challenge of presenting a unified group portrait. Here the boys' clasped hands, blue clothing, and obvious mutual interest are the keys that prevent this from becoming three separate paintings.

STEP ONE

1. After transferring the drawing to your paper, begin as usual by underpainting the boys' faces, legs and arms with a light-value wash of new gamboge and Winsor red.

2. Paint a light-value blue on the clothing of the boy on the left, and yellow on the clothing of the middle boy. This represents the sun-struck area. The boy at the right is in almost complete shadow.

STEP TWO

The sun is behind and over the boys' left sides, and their faces are almost completely in shadow.

1. Paint the shadow on the shirt of the boy on the right with ultramarine and cobalt blue. We must define the shadow with a hard edge, leaving the white of the paper for the shirt in sunlight. Describe these hard edges with cobalt blue and keep it wet, adding bits of rose madder and new gamboge near his right arm. Now use these colors for the stripes on the shorts as well as the socks on all three boys.

2. Use Winsor red and cadmium red for the center boy's shirt. Add cobalt at the shoulders, and new gamboge near the waist. Let the colors flow together on their own and dry undistrubed.

3. Now for the hair and the shadow side of the faces. Notice that the face of the boy on the right is receiving a warm reflected light from the shirt next to him while the boy in the middle is receiving light from the adjacent blue shirt. Do the hair and the face at the same time to keep a soft line between them.

4. Begin on the right. Wet the top of the head with clear water above the hairline. Start the face at the base of the neck with a fairly wet passage of new gamboge. Add a mixture of alizarin crimson and burnt sienna (value 4+). Stop just above the hairline and keep it wet. Now load your brush with burnt sienna right out of the tube (just a bit, don't gob it on) and define the hairline with vertical strokes following the contour of the head. Let the pigment just touch the premoistened top. In this way you will define the edge and keep it soft while the top remains a light value. Continue painting using less intense color: raw sienna and alizarin for the brown-headed boys.

5. The boy in the middle has blue reflected into his face. Use cobalt for this reflection then complete his hair as described above.

6. Use burnt sienna, Payne's gray, Winsor blue and sap green to describe the black hair of the boy on the left.

7. The children's arms are almost entirely in shadow, so the value will be four values darker than if they were in sunlight.

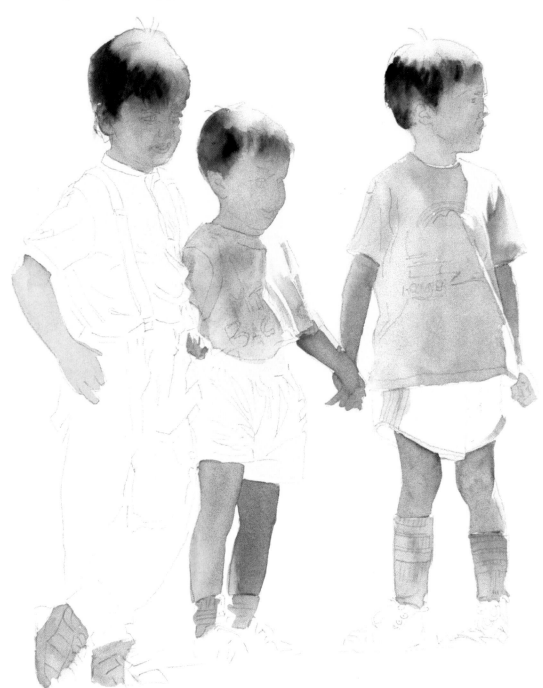

STEP THREE

1. The boy on the right has cadmium red shorts, and the boy in the middle has cobalt blue.

2. Paint the shadows across the sneakers of the boy on your left, then bring that color right up into his trousers, adding Winsor blue and ultramarine blue as you go. These lighter areas will help us describe the folds of the fabric later on. The shirt is a mixture of cobalt, ultramarine and Winsor blue. Keep the value a bit lighter under his arm to allow for a light bounce. Be careful to paint around the suspenders.

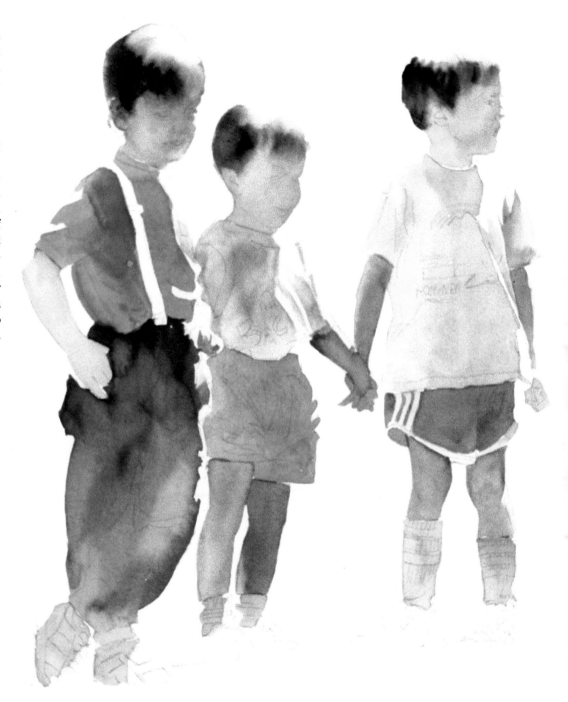

STEP FOUR

1. In such a small area you can only suggest the location of their features and locate dominant facial planes with alizarin crimson and burnt umber for the darkest places and various values of blue, crimson and sienna.

2. Paint the suspenders with cadmium red. Model the folds in the clothing on the shadow side. Use alizarin crimson and ultramarine blue, varying the proportions depending on the local color. Go slowly and think. You know, the best painting tool we have is our brain.

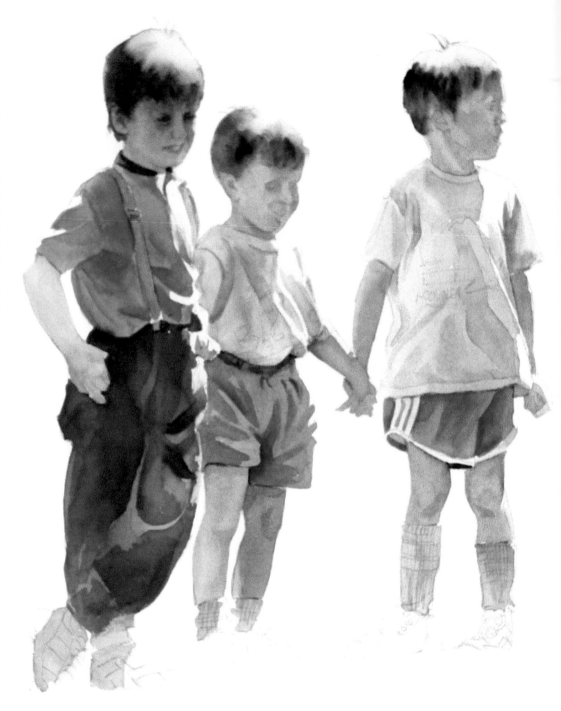

STEP FIVE

1. Paint in the sneakers with an appropriately dirty color. Add the details such as the crevice darks behind the ears, and under the cuff of the shorts.

2. Finally, do the lettering on the T-shirts and the stripes on the socks.

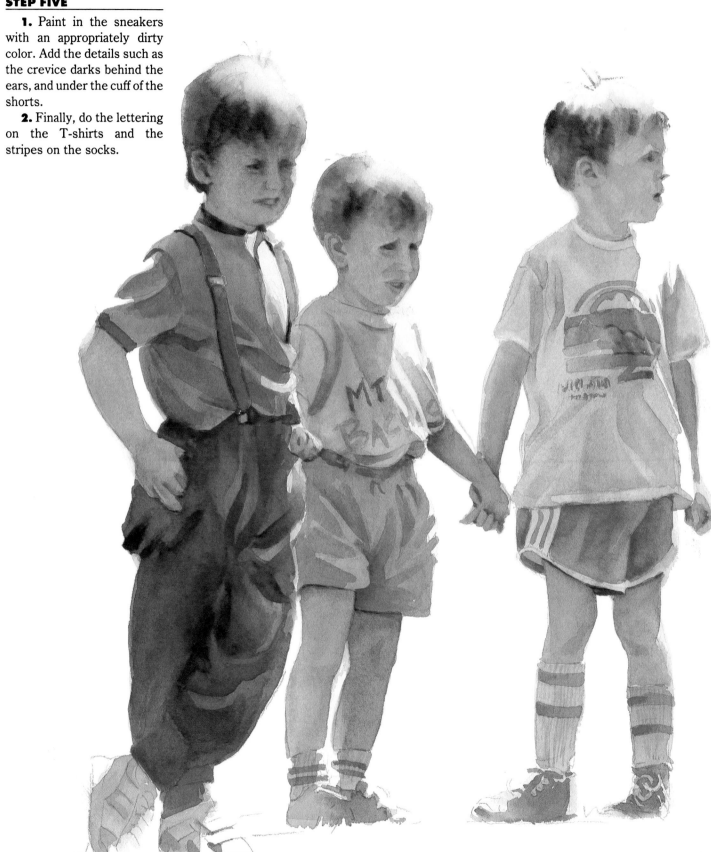

PRELIMINARY DRAWINGS FOR THE PROJECTS

TRANSFERRING THE DRAWING TO YOUR PAPER

There are two basic ways to transfer the preliminary drawings found on pages 70-81 to your watercolor paper.

If you wish to enlarge the drawing, first draw a grid (like a tic-tac-toe board but with twelve to sixteen boxes) over the drawing in the book. Then draw a similar grid, larger but with the same number of boxes, on your watercolor paper. The watercolor paper must be in the same proportions as the 8½″ × 11″ sheet in this book. If your paper is not, simply mask off a small strip so that you are working on a sheet with the proper proportions.

After drawing both grids with a ruler, simply copy the drawing in the book, box by box, onto your watercolor paper. It is best to use a light, medium-hard pencil like an HB to avoid exessive smudging.

If you would like to do your painting exercise the same size as the drawing in the book, you can transfer the drawing directly to your paper in the following manner. Prepare a graphite transfer sheet using a piece of good-quality tracing paper cut to a convenient size. Using the side of a soft pencil or a graphite stick, cover the back with graphite. Then rub with a tissue moistened with lighter fluid until you have an even coat. This transfer paper can be used over and over again.

Lay the transfer paper face down on your watercolor paper and lay the drawing you want to copy face up on top of the transfer paper. Secure the transfer paper and drawing lightly with tape so that they don't move around.

With a sharpened pencil, trace over the lines on the printed practice drawing using enough pressure so that the graphite on the transfer paper is transferred to the watercolor paper. Try not to smear the graphite. If you do, erase any smudges on the watercolor paper with a kneaded or plastic eraser.

Using the side of a soft pencil or a graphite stick, cover the back of a piece of tracing paper.

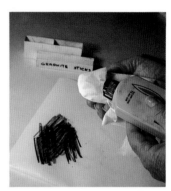

Moisten a tissue with lighter fluid.

Rub with the moistened tissue until you have an even coat.

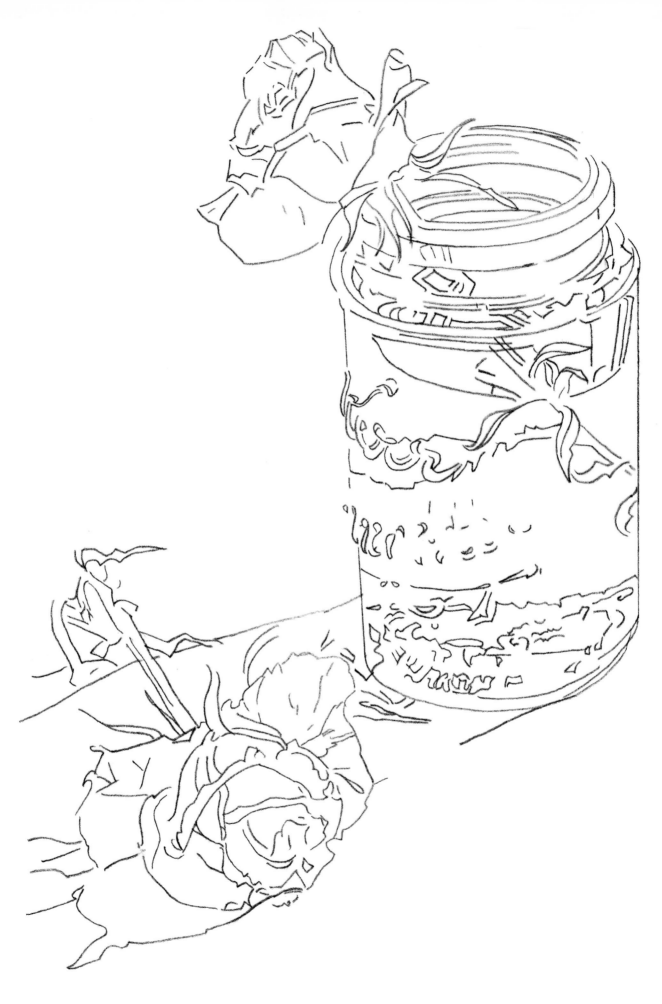

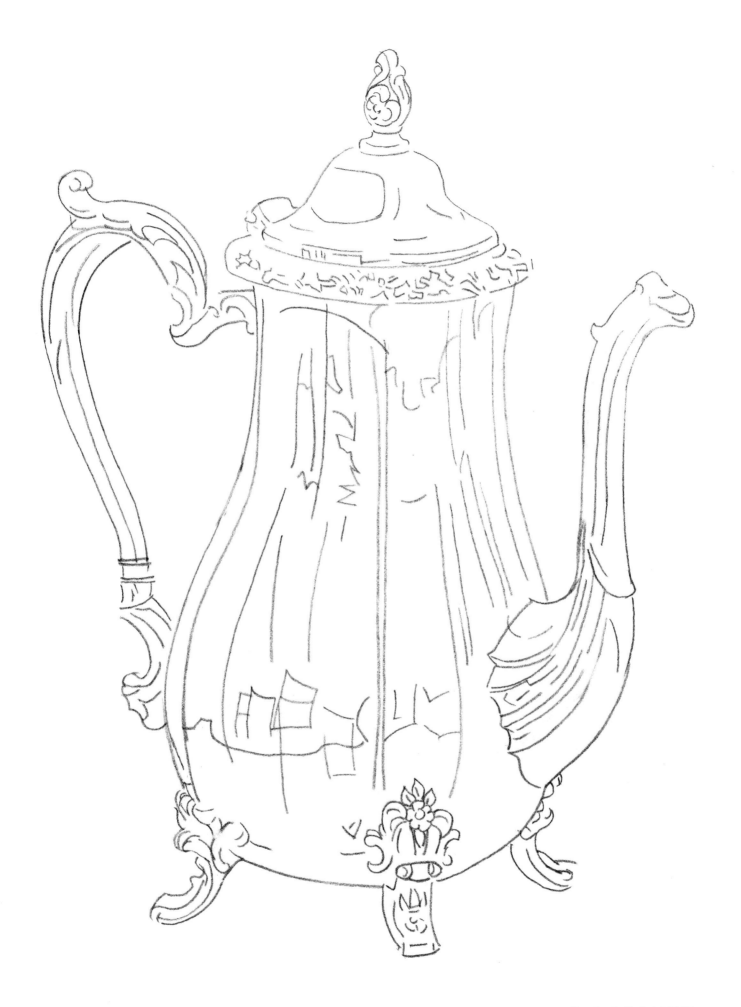

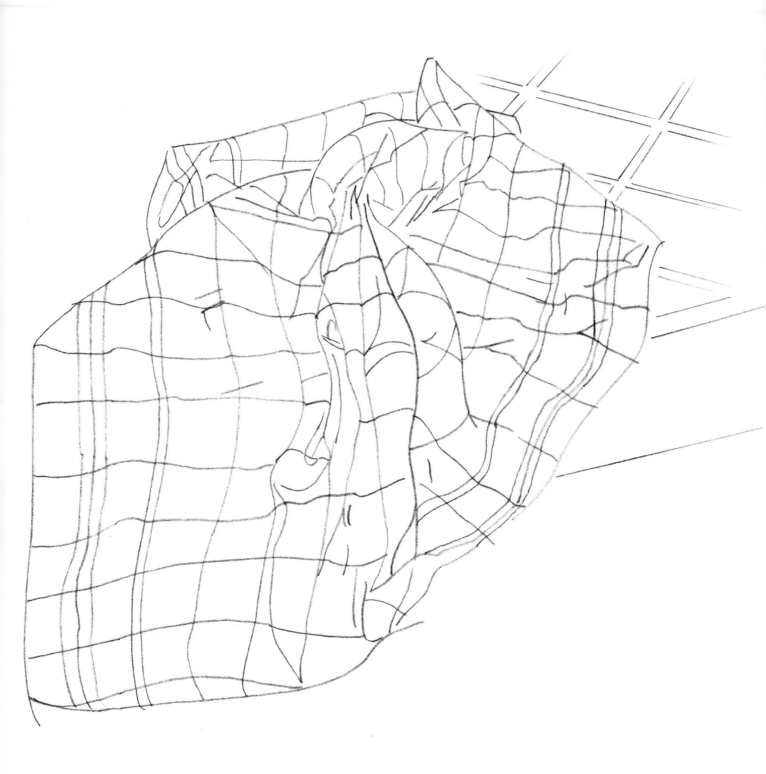

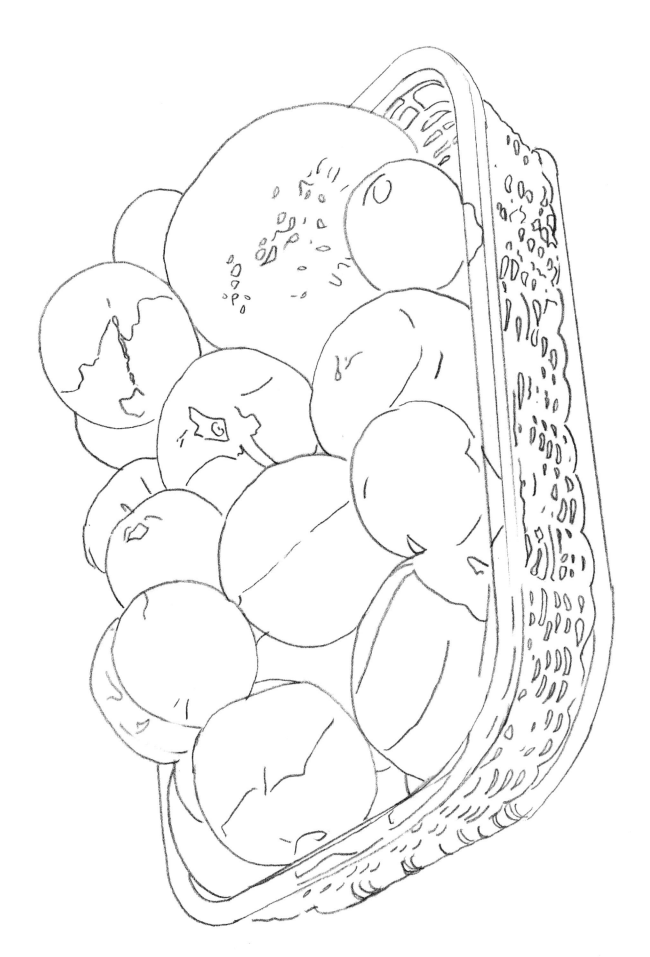

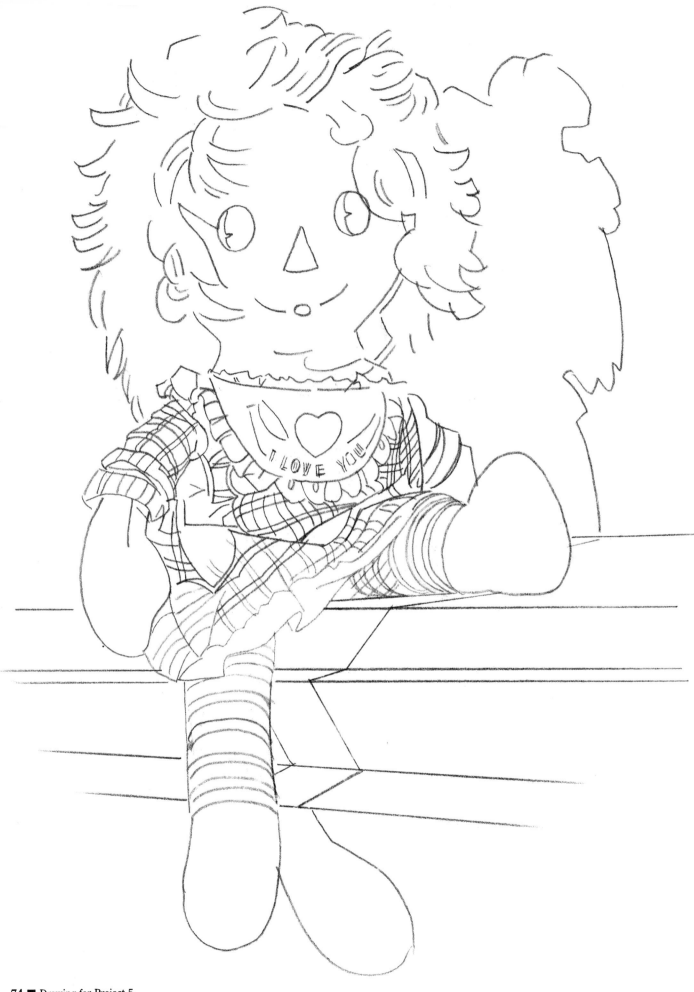

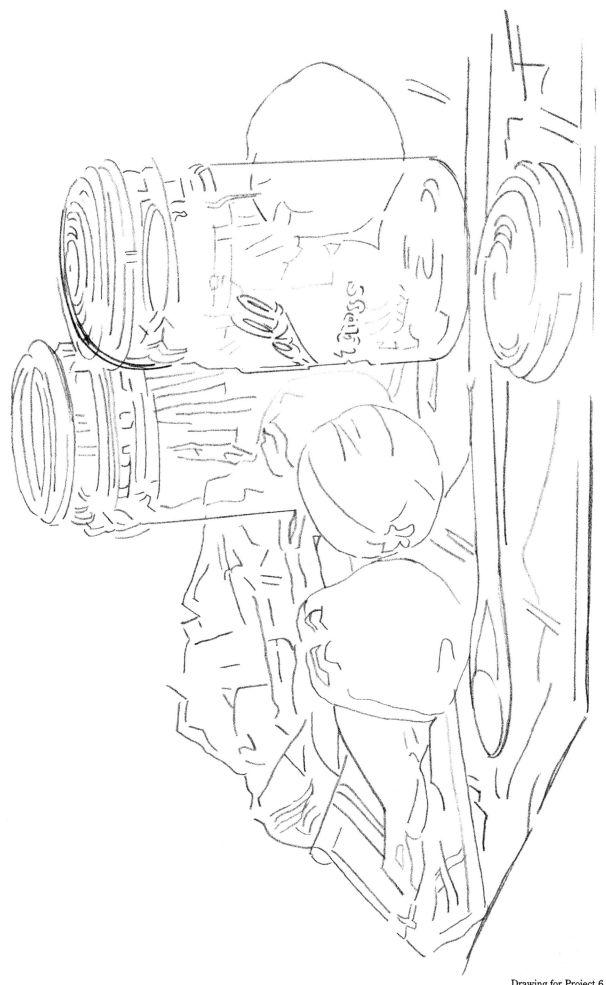

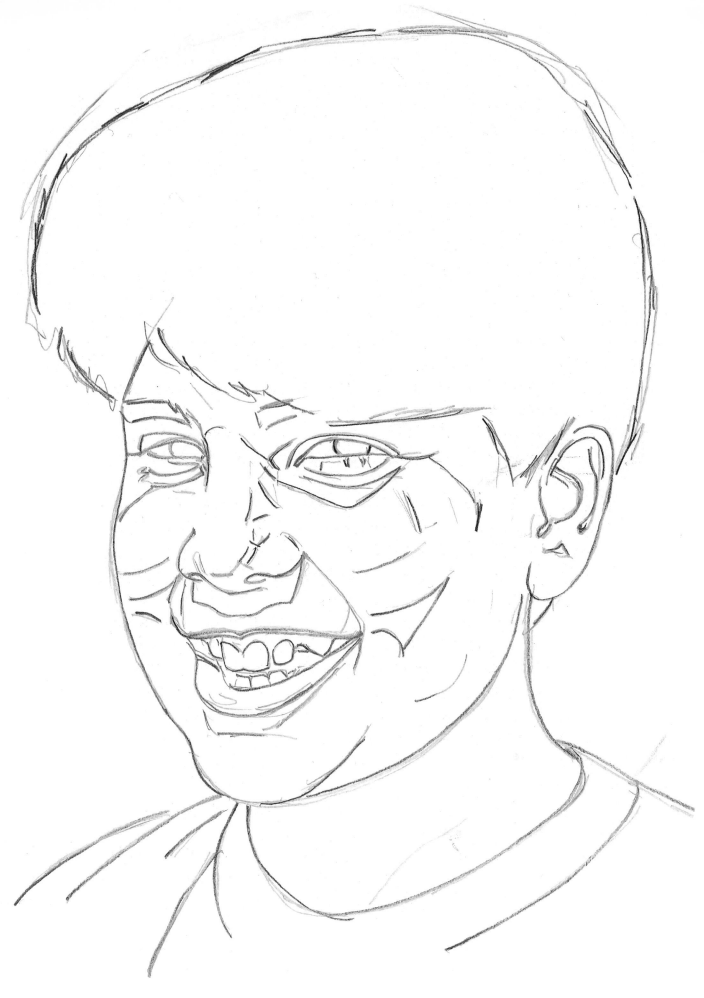

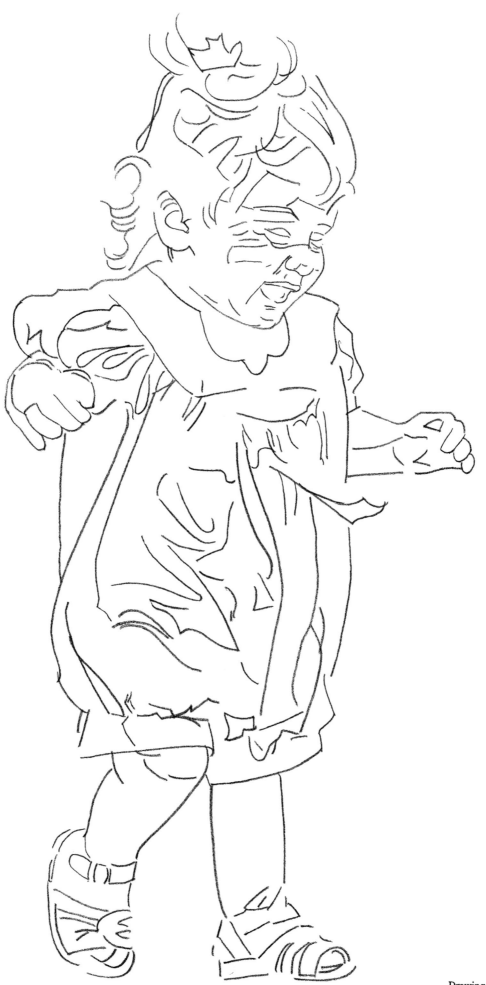

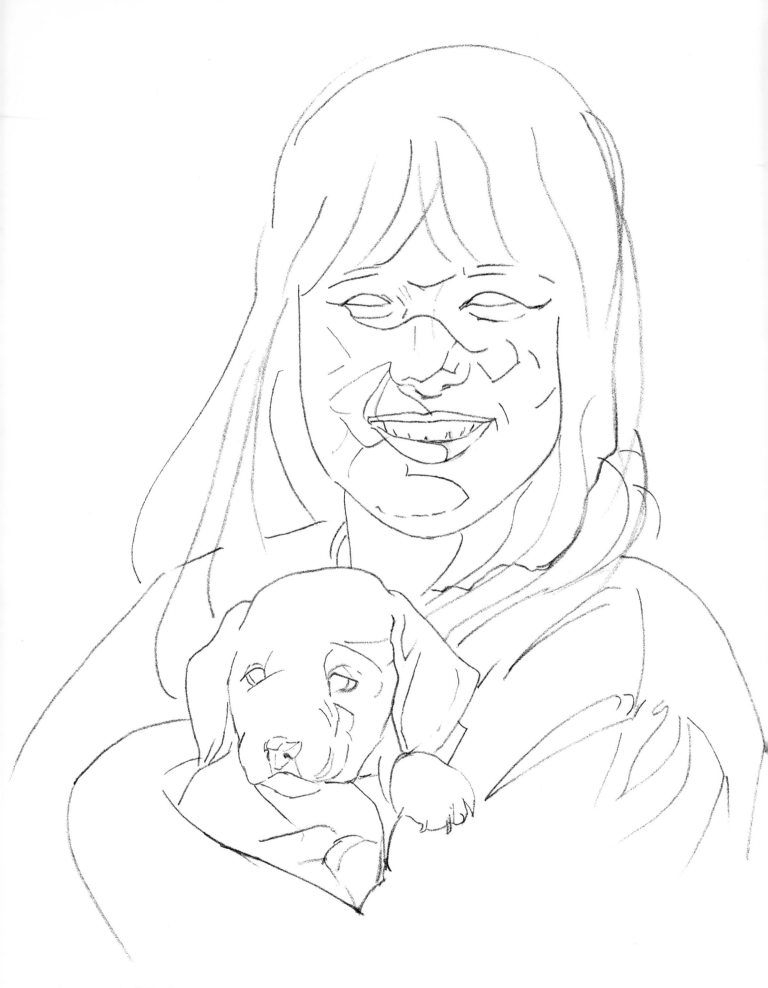

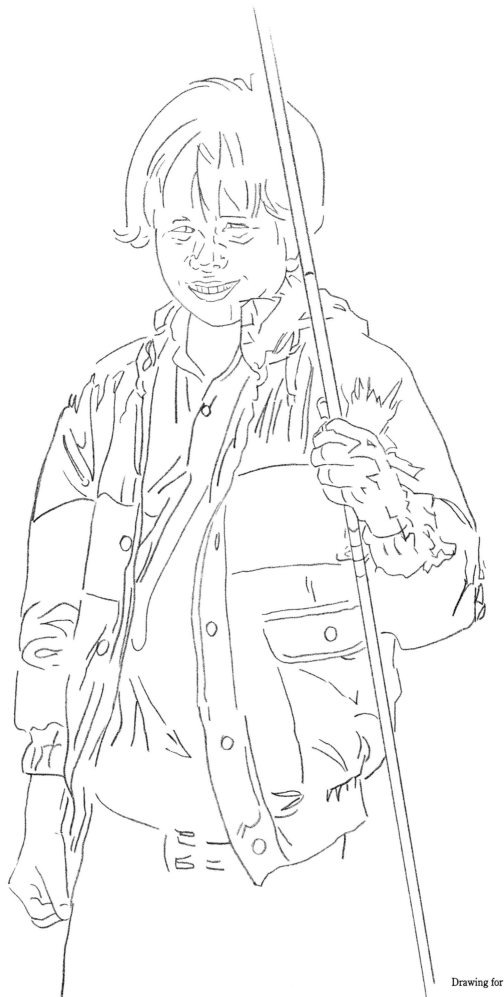

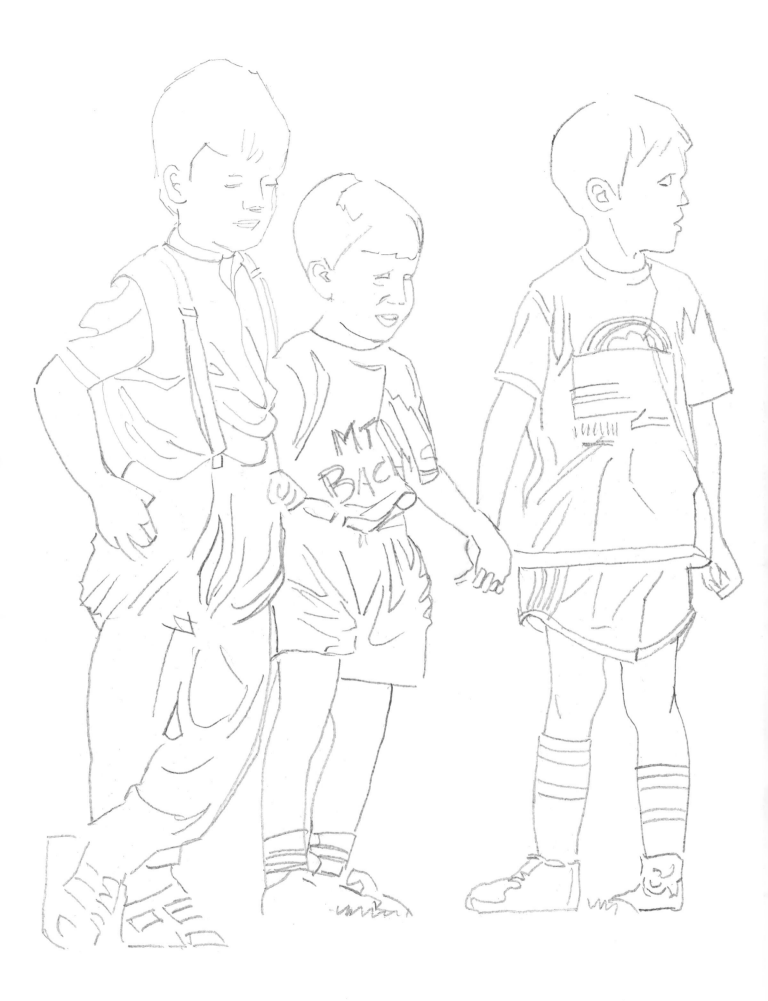

■ INDEX

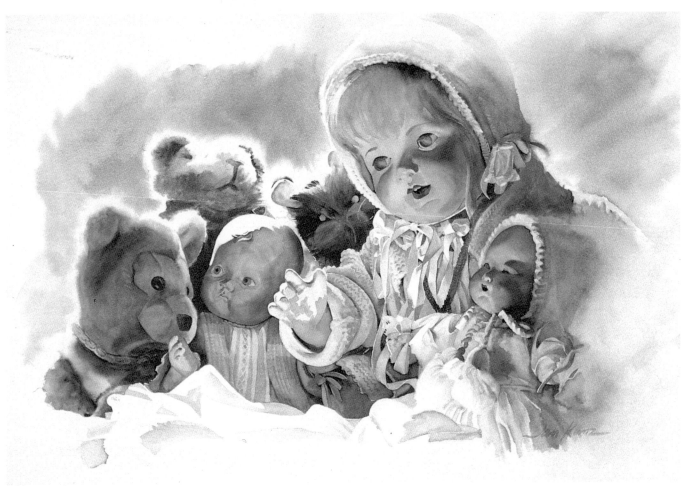

Mary's Friends
Jan Kunz 30" × 22"

Improve your skills, learn a new technique, with these additional books from North Light

Artist's Market: Where & How to Sell Your Art (Annual Directory) $22.95

Watercolor

Alwyn Crawshaw: A Brush With Art, by Alwyn Crawshaw $19.95
Basic Watercolor Techniques, edited by Greg Albert & Rachel Wolf $16.95 (paper)
Buildings in Watercolor, by Richard S. Taylor $24.95 (paper)
The Complete Watercolor Book, by Wendon Blake $29.95
Fill Your Watercolors with Light and Color, by Roland Roycraft $28.95
How to Make Watercolor Work for You, by Frank Nofer $27.95
Learn Watercolor the Edgar Whitney Way, by Ron Ranson $27.95
The New Spirit of Watercolor, by Mike Ward $21.95 (paper)
Painting Buildings in Watercolor, by Ranulph Bye $27.95
Painting Nature's Details in Watercolor, by Cathy Johnson $22.95 (paper)
Painting Nature's Peaceful Places, by Robert Reynolds with Patrick Seslar $27.95
Painting Outdoor Scenes in Watercolor, by Richard K. Kaiser $27.95
Painting Watercolor Florals That Glow, by Jan Kunz $27.95
Painting Watercolor Portraits That Glow, by Jan Kunz $27.95
Painting Your Vision in Watercolor, by Robert A. Wade $27.95
Ron Ranson's Painting School: Watercolors, by Ron Ranson $19.95 (paper)
Splash 2: Watercolor Breakthroughs, edited by Greg Albert & Rachel Wolf $29.95
Tony Couch Watercolor Techniques, by Tony Couch $14.95 (paper)
The Watercolor Fix-It Book, by Tony van Hasselt and Judi Wagner $27.95
The Watercolorist's Complete Guide to Color, by Tom Hill $27.95
Watercolor Painter's Solution Book, by Angela Gair $19.95 (paper)
Watercolor Painter's Pocket Palette, edited by Moira Clinch $16.95
Watercolor: Painting Smart!, by Al Stine $21.95 (paper)
Watercolor Tricks & Techniques, by Cathy Johnson $21.95 (paper)
Watercolor Workbook, by Bud Biggs & Lois Marshall $22.95 (paper)
Watercolor: You Can Do It!, by Tony Couch $29.95
Webb on Watercolor, by Frank Webb $22.95
The Wilcox Guide to the Best Watercolor Paints, by Michael Wilcox $24.95 (paper)
Zoltan Szabo Watercolor Techniques, by Zoltan Szabo $16.95

Other Mediums

Basic Drawing Techniques, edited by Greg Albert & Rachel Wolf $16.95 (paper)
Basic Figure Drawing Techniques, edited by Greg Albert $16.95
Basic Landscape Techniques, edited by Greg Albert & Rachel Wolf $16.95
Basic Oil Painting Techniques, edited by Greg Albert & Rachel Wolf $16.95 (paper)
Basic Portrait Techniques, edited by Rachel Wolf $16.95
Being an Artist, by Lew Lehrman $29.95
Blue and Yellow Don't Make Green, by Michael Wilcox $24.95
Bringing Textures to Life, by Joseph Sheppard $21.95 (paper)
Business & Legal Forms for Fine Artists, by Tad Crawford $4.95 (paper)
Capturing Light & Color with Pastel, by Doug Dawson $27.95
Colored Pencil Drawing Techniques, by Iain Hutton-Jamieson $24.95
The Colored Pencil Pocket Palette, by Jane Strother $16.95
The Complete Colored Pencil Book, by Bernard Poulin $27.95
Tony Couch's Keys to Successful Painting, by Tony Couch $27.95
The Creative Artist, by Nita Leland $22.95 (paper)
Creative Painting with Pastel, by Carole Katchen $27.95
Dramatize Your Paintings With Tonal Value, by Carole Katchen $27.95
Drawing: You Can Do It, by Greg Albert $24.95
Energize Your Paintings With Color, by Lewis B. Lehrman $27.95
Enliven Your Paintings With Light, by Phil Metzger $27.95
Foster Caddell's Keys to Successful Landscape Painting, by Foster Caddell $27.95
How to Paint Living Portraits, by Roberta Carter Clark $28.95
Keys to Drawing, by Bert Dodson $21.95 (paper)
Oil Painter's Pocket Palette, by Rosalind Cuthbert $16.95
Oil Painting Step by Step, by Ted Smuskiewicz $29.95
Painting Flowers with Joyce Pike, by Joyce Pike $27.95
Painting the Beauty of Flowers with Oils, by Pat Moran $27.95
Painting the Effects of Weather, by Patricia Seligman $27.95
Painting Vibrant Children's Portraits, by Roberta Carter Clark $28.95
Pastel Interpretations, by Madlyn-Ann C. Woolwich, $28.95
Pastel Painter's Pocket Palette, by Rosalind Cuthbert $16.95
The Pencil, by Paul Calle $19.95 (paper)
The Pleasures of Painting Outdoors with John Stobart, by John Stobart $19.95 (paper)
Sketching Your Favorite Subjects in Pen and Ink, by Claudia Nice $22.95
Strengthen Your Paintings With Dynamic Composition, by Frank Webb $27.95
Timeless Techniques for Better Oil Paintings, by Tom Browning $27.95
Tonal Values: How to See Them, How to Paint Them, by Angela Gair $19.95 (paper)
Welcome To My Studio: Adventures in Oil Painting with Helen Van Wyk, $24.95

To order directly from the publisher, include $3.00 postage and handling for one book, $1.00 for each additional book. Allow 30 days for delivery.
North Light Books
1507 Dana Avenue, Cincinnati, Ohio 45207
Credit card orders
Call TOLL-FREE
1-800-289-0963
Prices subject to change without notice.